Understanding the Art Museum

Barbara A. Beall-Fofana
Assumption College

PEARSON
Prentice
Hall

Upper Saddle River, New Jersey 07458

© 2007 by PEARSON EDUCATION, INC.
Upper Saddle River, New Jersey 07458

ISBN 0-13-195070-3

Printed in the United States of America

Contents

Introduction

Today Americans are fortunate to have access to many important art museums. These museums were, in general, founded on the principle of education, and, while many of the earliest began with reproductions, such as prints and plaster casts, the focus has long been on original works, bearing testimony to the importance our ancestors placed on learning from the objects themselves. Thanks to astute collecting over the past two centuries, including many generous gifts, America's art museums now rank among the finest collections in the world. These museums are among our nation's most important educational resources, yet relatively few Americans take full advantage of them.

The majority of Americans still have a rather narrow view of art museums that reflects a lack of understanding of the mission of these institutions as well as the important role of art in helping both to shape and interpret our world. Once you begin to explore these museums, you will learn that the objects within were selected not only for their aesthetic value but also for what they can reveal about humanity and the society in which they were created.

Art museums will continue to collect and preserve the best of world art, but their primary goal remains to assist the public in learning from these objects. Hopefully, more Americans will come to regard art museums like public libraries, the contents of which also serve as a gateway to the world. And just as we must learn to read to get meaning from text, so we must learn to look in order to gain a full appreciation of works of art.

Visitors to an art museum can take comfort in knowing that there are many ways of appreciating a work of art. While museums can assist by providing information about the work as well as the artist and the culture and period in which the work was created, the fact is that we will each take away something unique from these forms of visual expression. The museum's goal is to set the stage for a dialogue between the artwork and the visitor. As the educational philosophy of the Worcester Art Museum states, the museum aspires "not to give answers, but to ignite thought." In addition to providing an optimum setting for learning, art museums conduct ongoing research to further our understanding of art. This research has become increasingly exciting thanks to modern technologies, which help us to get closer to the artist's intentions.

In today's global society, where an appreciation of the various world cultures and religions is more critical than ever, art museums are especially valuable. In our galleries, we are able to compare and learn from many of the world's most meaningful objects, thereby gaining a greater perspective into the nuances of civilization. Art museums can also reveal much about the individuals and local communities that have created and sustained these collections. The architecture, the scope of the collections, as well as the programs of a museum—all tell a story that is increasingly valuable for understanding society.

The past century has witnessed the production of many textbooks on the history of art but few guides to assist students in maximizing their visit to an art museum. Therefore, it is a pleasure to welcome this useful introduction to art museums. This book is designed to familiarize you with the concept behind as well as the many dimensions of an art museum, and to help you begin a dialogue with its various treasures. It is a key to unlocking a resource that you can continue to enjoy and learn from well beyond your student years.

James A. Welu
Director, Worcester Art Museum

PREFACE
Experiencing the Museum and the Art

This book is written to you and for you—a person with an interest in visiting a museum and learning more about how to make that visit a richer, more meaningful experience.

This book is based on the idea that the best experience is an interactive one. The three major components of that interaction are you, the art, and the museum. This interactive formula works only if you, the viewer/visitor, are fully engaged and have some basic information, or "tools," to help you look at and interpret the art and understand the museum.

Your Perceptions of the Art and the Museum

When you think about a museum, do you consider it to be an exciting place to visit or an hour or two you'll have to tolerate? Will going to a museum be a new experience for you? Or have you visited one—or several—before? The idea of visiting a museum may feel pleasantly familiar or uncomfortably strange. It is useful to acknowledge our own preconceived ideas and opinions because these will influence how we appreciate both the museum and the art.

If you can open yourself—your mind and your spirit—you can learn to see with an informed eye. The world of the museum and of art offers an exciting visual experience of what was important, valued, and considered beautiful to people in other cultures and times. Through the study of art and the museum-going experience, you will discover art that moves you, inspires you, takes your breath away, makes you turn away in shock, and forces you to think in new ways.

The Content and Organization of This Book

This guidebook's primary goal is to demystify and to enhance your experience of the museum and the art, providing you with the tools you need to look at, discuss, and write about both.

The guide is divided into three sections:

Section I is called "You and the Museum." The chapters within discuss your interaction with the museum; included are a brief history of museums in the West, the significance of the siting and the physical structure of the museum, the protocol of visiting a museum, and the information the museum provides to you.

Section II, "You and the Art," focuses on the viewing and understanding of the art, selecting a work of art for a paper, and ways to discuss, analyze, and interpret art.

Section III, "You, the Art, and the Museum," reflects on the interactive experience and some of the future challenges facing art and the museum.

At the end of each chapter are "For Your Consideration" topics—suggestions and concepts to research, discuss, and write about. Some chapters also feature a "Case Study" that either includes a more in-depth examination of a particular artwork, highlights special concerns or theories discussed in the chapter, or both.

Whatever, your past experiences, I hope that this book will influence your present and impact your future encounters with art and museums. Remember, you are the key to the interaction of you, the art, and the museum.

Barbara A. Beall-Fofana
Paxton, Massachusetts, 2006

Acknowledgments

Understanding the Art Museum sprang from my experiences as a student and teacher of art history and my on-going commitment to teaching from the actual art and architecture. My students' enthusiasm for learning from the art itself, coupled with their obvious engagement with the material, prompted the creation of a survey course titled "Museum-Based Art History."

This museum-based course is made possible by continued support from the Worcester Art Museum. Special thanks goes to James A. Welu, Director of the Worcester Art Museum, who wrote the preface to this book. In addition, my thanks to the committed staff at the Worcester Art Museum who make the collections accessible to the public and work collaboratively with educators and educational organizations in the area. Thanks also goes to Debby Aframe, who continually assists my students and me at the museum's library, and Jordan Love, who patiently assisted me in accessing numerous curatorial records in preparation for teaching from the museum's collection.

The direct impetus to begin this book came after discussions with Helen Ronan, Sponsoring Editor–Art History for Prentice Hall Higher Education, with whom I shared my excitement over the survey course. She in turn shared this with Sarah Touborg, Editor in Chief for the Arts, who subsequently invited me to write this book. I thank them both for this opportunity. I must also thank Mary Ellen Wilson, who joined the project as my copy editor but added much with her insightful editing. Her comments and suggestions were helpful, lucid, and always expanded my thinking and, I hope, my writing.

In addition I owe my appreciation to the administration and members of the Faculty Development Committee at Assumption College for supporting my teaching and course development in spirit and by awarding me a Faculty Development Grant targeting curriculum development. Complementing that has been the enthusiasm from my own Department of Art and Music and formative conversations in my first postgraduate experiences teaching art history survey courses at Providence College in Rhode Island with a phenomenal team of insightful colleagues, Alice H. R. H. Beckwith, Joan R. Branham, Deborah J. Johnson, and Anne Wood Norton.

My thanks to my art history professors at Brown University and the Department of Art History, especially my dissertation advisor, Sheila Bonde, Dean of the Graduate School, and those at the University of Massachusetts, Amherst. They all taught me how to articulate my love for art, to carefully examine the interpretation of art, and, above all, to always remember the importance of the primary evidence—the art itself.

My own students also deserve thanks, for they were the inspiration for this book. Their questions, comments, and insights helped me in determining how best to facilitate the interaction and communication among student, teacher, art, and museum.

I would also like to recognize the contributions made by my late husband, Herbert Beall, who left a legacy in writing-across-the-curriculum in addition to his own

research and publications in chemistry. He was a boundless source of writing strategies and my best writing teacher. And, finally, I extend my heartfelt and grateful thanks to my dear husband, Mustapha Said Fofana, who encouraged me to "pick up my pen" once again and complete this book while offering his endless patience and support.

Barbara A. Beall-Fofana
Assumption College, Worcester, Massachusetts, 2006

YOU AND THE MUSEUM

CHAPTER **1**

Defining the Art Museum

What comes to mind when you think about an art museum? Do you picture a building or a website or both? This chapter investigates the Western tradition of museums and collections as well as a newer addition—museums in cyberspace. Museums today often exist in more than one form—the real and the virtual.

The "real" form refers to the physical building, its location, and the objects contained within. This "brick-and-mortar" museum is the focus of this book. But understanding the role and contribution of the virtual museum—websites sponsored by the museum—is also useful. Both types of museums are important resources, and each provides specific opportunities to experience and study art.

Why Do People Collect?

First and foremost, museums are collections of objects. Many people enjoy gathering groups of things they find appealing. And there are as many reasons for collecting as there are collectors. Yet the motivations to *acquire* and *inquire* are directly linked. Bringing together objects—or the material culture that represents aspects of our lives, cultures, and worlds—is often the result of collectors who want to learn, teach, and educate. Some collectors may hope to gain status from assembling a particular type of collection. Whatever the impetus, the establishment of personal collections of a wide range of objects, including art, is the predecessor of today's art museums. Over time, the type of collectors and the focus of collections have shifted from being private enterprises to public institutions.

A Brief History:
From the Classical *Mouseion* to Today's Museums

Where did the word *museum* come from and what does it mean? It derives from the Greek word *mouseion*, which has its roots in the Greek word meaning "the seat of the Muses." In classical Greek mythology, the Muses were the nine daughters of Zeus, the supreme male god, and Mnemosyne (Memory), a female Titan. The ancient Greeks believed that the Muses inspired mortals in the acquisition of knowledge and in the creation of the arts, especially music and poetry. So *mouseion* referred to a

1

place associated with what the Muses inspired—the arts—and dedicated to learning and philosophical contemplation.

The modern word *museum* is derived from *mouseion*, as used by the ancient Romans. For the Romans, this place for philosophical discussions and thought became more like a library and then a teaching institution. One early example is the Museum of Alexandria in Egypt, founded in ancient times by Ptolemy I Soter, which housed a library and served as a site where scholars gathered.

The Cabinet of Curiosities and the *Kunstkammer*

Over time, the use and meaning of the word museum has changed from indicating a place of philosophic contemplation to one in which individuals and organizations house objects they have collected for study. The forerunners of today's museums can be traced back to the Middle Ages and the private collections of princes and other aristocrats as well as the treasuries of medieval churches and cathedrals. By the 1400s, a new group joined the ranks of the elites. Members of the well-to-do merchant classes wishing to emulate the aristocracy began amassing their own collections. By the 1500s, anyone wanting to be considered a learned, prominent citizen needed to establish a private collection or cabinet, sometimes called a "cabinet of curiosities," *Kunstkammer* (art room), or *Wunderkammer* (room of wonders).

Because modern-day museums often specialize in specific types of art, these early collections may seem surprisingly diverse to us today. In addition to acquiring art, medieval and Renaissance collectors gathered objects representing natural history and the history of the world. Surviving inventories reveal the depth and breadth of these collections, with objects ranging from bird nests to gems and coins to prints, sculpture, and paintings (**Fig. 1**). Despite the diversity of the collections, scholars agree that all shared a common goal—to encapsulate and comprehend universal knowledge. To achieve this aim, people collected natural and human-made objects that represented every area of knowledge in the known world. Although the type and range of objects collected depended on the interests and resources of the individual, in the 1500s Samuel Quiccheberg (1529–1567) published a groundbreaking treatise that offered guidelines for establishing an ideal, encyclopedic collection. He divided the ideal collection into five categories: the first included religious art in all media; the second, sculpture, archaeology, numismatics, and the applied arts; the third, natural objects and original specimens as well as such artifacts as minerals, fossils, and shells; the fourth, science and mathematics tools and instruments, such as globes, astrolabes, and clocks as well as material related to games and pastimes; and the fifth, painting and engraving, which corresponded to an "art" collection.

A major shift occurred in the 1600s as some of these private collections became public. Among the most important transfers was the purchase in 1661 by the city of Basel, Switzerland, of the cabinet of curiosities owned by Basilius Amerbach (1533–1591) to prevent it from being sold and moved to Amsterdam. The so-called Amerbach Cabinet included many drawings and prints as well as approximately 50 paintings, with 15 by the noted German artist Hans Holbein the Younger (1497/8–1543). This purchase was noteworthy because it marked an early example of civic concern that collections remain for the long-term benefit of the city and its

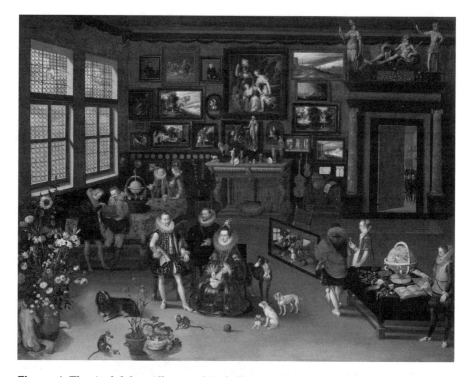

Figure 1 *The Archdukes Albert and Isabella in a Collector's Cabinet* is a depiction presenting an encyclopedic collection of curiosities and art. Frans Francken II and workshop with Jan Brueghel II, *The Archdukes Albert and Isabella in a Collector's Cabinet*, about 1626. Oil on panel, 37 × 48-9/16″. The Walters Art Musuem, Baltimore, MD. Museum purchase, 1948. 37.2010

citizens. The collection eventually formed the core of two existing museums: the art became the foundation of Basel's Kunstmuseum (art museum), and the rest of the cabinet formed the basis of the Basel Historical Museum. Another such transfer occurred in 1675, when Elias Ashmole (1617–1692) presented his personal, encyclopedic collection to the University of Oxford. A building constructed to house the collection opened to the public as the Ashmolean Museum in 1683. During the 1800s the natural history specimens were moved to form the central collection of the Oxford University Museum of Natural History, and the other portions of the collection became part of the Ashmolean Museum of Art and Archaeology.

The transition in the collecting world from private to public became more widespread, indicating a conscious desire to increase accessibility to the collections. Instead of restricting access to a select elite, a greater number and range of people could now view the objects and learn from them.

Museums in Modern Times

The importance of these encyclopedic collections to the transfer of knowledge was paralleled by the Age of the Enlightenment in the 1700s and 1800s. This European

intellectual movement stressed humanity's reliance on reason and scientific knowledge to improve its condition. Among the movement's specific goals was the acquisition of knowledge. Often cited as one of the best examples of Enlightenment thought was the 35-volume Encyclopédie published between 1751 and 1780; French philosopher Denis Diderot (1713–1784) edited the first 28 volumes. In the ninth volume Diderot advocated for a national museum in France. The museum had thus become an integral part of the Enlightenment project, providing in physical form what the *Encyclopédie* promoted in text.

In the 1800s and 1900s, comprehensive collections in museums made knowledge available to a growing public while inspiring pride and a sense of identity in many newly formed nations. Two European museums began this trend when they opened their doors to the public—the British Museum in London in 1759 and the Louvre in Paris in 1793. Founded as expressions of the Enlightenment, both institutions became important showcases for their nations, and art was gaining a predominant and revered place within each. The European museum movement attracted likeminded individuals across the Atlantic as well. American colonial artist Charles Willson Peale (1741–1827) established a museum in 1784 and opened it to the public. Like a cabinet of curiosities, Peale's museum exhibited his own paintings in addition to minerals and whalebones. In 1814 his son Rembrandt Peale (1778–1860) opened the Baltimore Museum and Gallery of Fine Arts, which is now the Peale Museum in Baltimore, Maryland.

Eventually individuals and institutions began placing more emphasis on forming collections of art and displaying art separately. In 1832 Yale University opened a museum dedicated solely to the exhibition of art. Subsequent public art exhibitions were linked to libraries that had developed art collections and displayed them in separate galleries. The Boston Athenaeum, established as a library in 1807, supported art exhibitions from 1826, and in 1842 the Wadsworth Athenaeum in Hartford, Connecticut, not only added an art gallery but also began to collect paintings.

Art collections continued to be linked to libraries, universities, and academies of art. By the later 1800s large, public museums in urban centers such as Chicago and New York began displaying art. Rising from the ashes of the Chicago fire of 1871, the Chicago Academy of Fine Arts opened as a school in 1879. It soon modified its purpose, established an art collection, and changed its name in 1882 to the Art Institute of Chicago. In New York, the Brooklyn Museum opened a gallery of art in the 1850s, and in 1870 the Metropolitan Museum of Art was opened.

The establishment of separate collections of only art and the concept of a museum focusing on the display of art are late additions to the history of museums. Nevertheless, art museums are now firmly established in our society and around the world.

What Art Museums Are Included in This Book?

This book focuses on museums within the United States that are dedicated to the preservation, exhibition, and interpretation of art. Some have art collections spanning a wide period and representing many cultures, resulting in an "encyclopedic" art col-

lection, such as the Metropolitan Museum of Art in New York City. Others target more specific types of art, such as the Asian Art Museum of San Francisco, which is devoted exclusively to the display of art from Asian countries.

The Virtual Museum

Many museums sponsor virtual sites on the World Wide Web. Making large portions of the collection accessible to people around the world, these websites are a powerful, interactive tool for studying art. They also provide practical information, such as museum hours, directions, policies, departments, and services. Many provide hyperlinks that may direct you to the museums' own departments or to other museums, libraries, and related sites.

Virtual museums offer many opportunities for study and research, but they also have important limitations. Many include only a portion of the museum's collections, and online images may be small and of poor quality. And nothing compares to seeing and experiencing a work of art or architecture firsthand. You can't truly appreciate the physical qualities of an artwork online—its scale, the quality of line, or the medium. The artwork's subtle physical attributes and its relationship to the viewer are impossible to experience virtually. Nevertheless, the virtual museum offers a good starting point for gathering information before you view the work in a museum setting. It also permits visual access to more fragile types of art—prints, drawings, photographs, textiles, watercolors, and pastels-that can be exhibited for only brief periods because of sensitivity to light, humidity, or other environmental factors. From your own dorm, home, or office, the virtual museum opens the door to countless art images for study and comparison.

Conclusion

In many ways the art museum has come a long way from the ancient Greek *mouseion* and the medieval and Renaissance cabinets of curiosities. The focus has changed from the comprehensive collection of objects representing the natural world, including art, to the art itself. You have also learned that the ownership of museum collections has largely shifted from individuals into public hands. Throughout these many changes, the present-day art museum is still a place for contemplation, and its mission remains to help us learn about and reflect on the world around us through the exhibition and interpretation of art.

For Your Consideration

Select three art museums, visit their websites, and compare and contrast what each offers through its virtual site.

Write a brief essay explaining the purpose of the private comprehensive collections established during the Middle Ages and the Renaissance. Be sure to include examples of the diverse objects in the collections and identify who did the collecting and why.

Research the virtual collection at one of the large, urban museums (such as the Museum of Fine Arts in Boston, the Los Angeles County Museum of Art in California, the British Museum in London, the Louvre in Paris, and so on). Discuss the breadth of art in the collection and explain what that tells you about the museum's mission.

CHAPTER 2
Mapping the Museum

Have you ever considered how the museum building affects your experience with the art? All of us bring our own thoughts, feelings, opinions, and knowledge with us when we visit a museum. But some of your thoughts and feelings about the museum are a direct result of what the building communicates to you. Before you ever enter the building or look at any of the art, you have already been sent important messages.

First, an interaction occurs between you and the architecture. Your experience is shaped not only by the museum's structure—its architectural style—but also by the site it inhabits and its relationship to the surrounding buildings and landscape. Other features also communicate with you, such as the way in which the entrance introduces you to the museum, your movement through the interior space, and the relationship between the architecture and the art.

Let's step back and learn to interpret and analyze these messages. The museum itself is architecture, or the built environment. What is exciting about architecture is that you experience it in several dimensions. First you encounter it spatially in three dimensions. But you also experience architecture in another dimension—time. You cannot see all aspects of a building at once. The physical experience unfolds over time as you approach the museum, enter it, move around it, and eventually leave it.

How Does the Museum Welcome You?

When you enter any building, the architecture guides you. Take note of how the design of the building dictates where and how you proceed. Moving through the museum is like a dance, and the structure of the building choreographs your steps.

First, as with most buildings, physical markers usually indicate the main entrance. For example, an impressive walkway or flight of stairs may lead to the entry, or an architectural feature such as a large door or grand archway may announce its location. Once inside, notice how the museum greets you. Is there a grand, imposing foyer or is the entry on a more human scale? Is the objective to inspire awe or familiarity?

Navigating the Museum

Feel free to explore the museum at random, allowing the architecture to guide your path through the galleries. Or you may find it useful to follow a printed ground plan of the museum, which is usually available where you enter and buy your ticket. These guides provide a map of the galleries and exhibition spaces, and they will help you in planning your visit. Before embarking on your journey, take time to study the ground plan and notice how the galleries are organized. The ground plan reveals what is considered important in the museum—the scope of the collection and the way the art is

grouped or classified. The largest, most impressive galleries will often contain the strengths of the museum's collection.

Many American museums constructed in the 1800s represent a wide range of art. The design of the galleries moves you through the collections chronologically. For example, the galleries may be arranged beginning with ancient Egyptian and Near Eastern art, followed by Classical art of ancient Greece and Rome, and then Medieval, Renaissance, and Baroque art. For the 1600s and later, you may see art grouped according to the century and country or region, such as 17th-century Dutch, 18th-century English, 19th-century French, and 20th-century German art. Twentieth-century art is often divided into specific artistic movements, such as Abstract Expressionism, Pop art, and contemporary art, or it may be arranged according to particular types of media such as prints, drawings, and photographs. In many U.S. museums, the arts of non-Western countries, such as those of Asia and Africa, and the arts of Aboriginal or Mesoamerican or Native American cultures are displayed in their own galleries.

The hypothetical museum described above clearly places an emphasis on constructing an encyclopedic collection of art. The art selected reflects a Eurocentric, or Western, perspective that gives prominence to works created by artists from Europe and the United States. The objects collected primarily represent Western culture, and their presentation in chronological order replicates the traditional study of art history. In contrast, some museums are arranged thematically, such as the National Museum of the American Indian or the Smithsonian Museum of African Art in Washington, D.C., presenting an alternative method of experiencing the art.

Special Exhibitions

Many museums also have specific galleries for the display of special exhibitions on view for brief periods, either a few weeks or a few months. A special exhibition often brings together art from collections around the world. These exhibitions may be organized around a specific theme and allow greater access to art not usually seen together, thus encouraging new ways of thinking about the works.

Museum Protocol

You may notice that when people are looking at and thinking about art, the atmosphere is fairly tranquil. Most museums are meant to be places for quiet viewing and contemplation. Some may offer separate rooms where the atmosphere is more relaxed—you may be able to use computers, explore examples of materials for making art, or participate in other interactive activities. Note that for special exhibitions, museums may restrict the number of people in the gallery. This precaution is done not only for the safety of the art but also for the comfort of the visitors.

At each museum you visit, you will likely notice some written and nonwritten rules that visitors are expected to follow. Be sure to check the museum website or call or write for specific policies. Although these regulations vary, the following points will give you some idea of what to expect.

WHAT TO DO IN THE MUSEUM

- Look at the art! Access all public spaces and examine, study, and contemplate the art that attracts you.
- Take advantage of public seating to relax and take everything in.
- Bring a notebook and always use pencil when writing or sketching in the galleries.
- Ask for special permission to use art materials such as charcoal, paint, or an easel.
- Leave a respectful distance between you and the art.

WHAT IS NOT PERMITTED IN THE MUSEUM

- Touching the art—this is strictly prohibited.
- Bulky bags, backpacks, art portfolios, umbrellas, or any items that may harm the collections.
- Ballpoint or marker pens.
- Food, gum, water, or other consumables.

A note about touching: In the interest of preservation, do not touch any artworks in museums. Our hands contain harmful oils that can damage or wear away surfaces over time. Museum guards will likely become concerned if you approach or wave your hand too closely to artworks. Be aware that some objects are fitted with sensors, and a high-pitched alarm will sound if you get too close. It will probably startle you and bring a guard to your side immediately. Remember that museum guards have a difficult job of protecting the art while allowing visitors to enjoy their museum-going experience. So try not to get too close to or point with your finger or other object.

Admission

Most museums charge an entrance fee, with discounted rates for special groups, students, and seniors. Many have certain hours when admission is free, and some also have a suggested fee for which the visitor determines what he or she can pay. Disabled visitors have access to most museums, but the ease varies and a particular entrance may be required. Call ahead to verify.

Photography

Photographing the exterior of the museum is allowed, but taking pictures inside usually requires permission. Flash cameras are not permitted because of the potential damage from the bright light. If you wish to take your own photos, bring a single-lens reflex camera with fast film or a digital camera.

You may also purchase photographs or slides produced by the museum. Be aware that permission for your own or the museum's photographs is given for per-

sonal use only and not for publication of any sort. In addition, many artists and their heirs (if the artist is deceased) hold copyright to the original work of art. They too must grant permission for its reproduction.

Remember that in either case permission extends only to the art owned by the museum and does not apply to many special exhibitions or any works on loan. Verify ownership of individual works by looking at the museum label (see Chapter 3). If you wish to use your photographs for commercial use or publication, you will need written permission from the museum. You should contact the museum's Rights and Reproductions or other photo services department to request permission, purchase materials, clear copyright, and pay necessary fees.

Case Study:
Learning to Interpret the Messages

As you've read in this chapter, the site and architectural style of museums send important messages about their mission, function, and contents. Let's take a closer look at these ideas by comparing and contrasting two museum buildings, the Metropolitan Museum of Art in New York City (**Fig. 2**) and the National Museum of the American Indian in Washington, D.C. (**Fig. 3**).

Figure 2 The present main facade of the Metropolitan Museum of Art incorporates Classical architectural elements to emphasize its importance and its permanence.

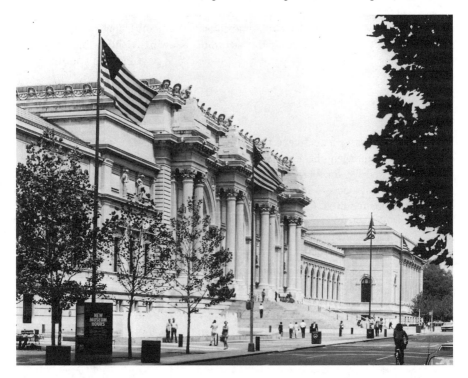

The Museum Site

The location of the Metropolitan Museum of Art near Central Park in New York City has remained the same, but the site and the building have been modified greatly since the museum's founding in 1870. At that time, the adjacent area was much more like a park and the original Gothic-revival style building would have been visible from a great distance. But in the intervening years both the building and the city expanded. The Metropolitan Museum's current main facade faces Fifth Avenue and stretches four city blocks. Today, it is hard to see the museum from a distance. But when you do, its massive scale indicates its importance and symbolizes its permanence.

In contrast, the National Museum of the American Indian is a recently-constructed building that opened in 2004. Located in the heart of Washington D.C., it is sited prominently on the Mall and is flanked by other national museums such as the National Gallery of Art and the National Museum of Science and Industry. The area also includes major governmental buildings such as the U.S. Capitol.

What Does the Museum's Architecture Communicate?

The choice of a museum's architectural style likely depended upon when it was built or modified as well as how the museum administrators, board of directors, and architect(s) wanted you to perceive the museum.

Figure 3 The curvilinear shapes of the entrance facade of the National Museum of the American Indian echo the natural formations of mesas and caves, accentuating the building's connection to nature. ® TIM SLOAN/Agence France Presse/Getty Images.

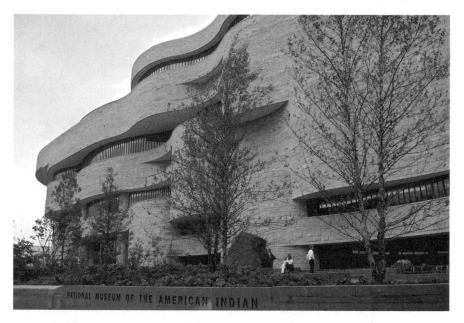

Many American museums were founded in the late 1800s and early 1900s, and their buildings display a classical-revival style then popular in the country. This style incorporates architectural elements from ancient Greek and Roman buildings and evokes the grandeur, stability, and long duration of these revered civilizations in Western history. The present architecture of the Metropolitan Museum of Art makes many references to classical buildings. Expanded in the early 1900s by Richard Morris Hunt and the firm of McKim, Mead, and White, the current design replaced the earlier Gothic-revival building. The present imposing facade of monumental scale, with its huge, rounded archways and colossal Corinthian columns, recalls the massive ancient baths of the Roman Empire. The long, central stairway leading to the main entrance recalls the podium leading to the entrance of Roman temples. Such imperial features declare this building's permanence and importance and tell you that what is contained within this "temple" dedicated to art should be revered.

The National Museum of the American Indian also had many individuals, architectural firms, and interested groups involved in its design. Given the focus of the museum, planners sought input from Native American leaders, artists, and communities, as well as architects with direct experience of Native American concerns and culture. The themes that emerged—notably the importance of a direct connection to nature—influenced many of the decisions regarding the building's design. The building is aligned to the cardinal points and celebrates its connections to nature through its physical design and decorative elements. The main entrance facade boldly draws your attention with a series of curvilinear shapes that alternately advance and recede into space, suggesting the natural formations of mesas and caves. Even the limestone, with its rough and smooth surfaces, was carefully selected to evoke visual images of the walls of river-carved canyons. Symbolically, the facade faces both the rising sun as well as the U.S. Capitol. The exterior stone pathway leading you to the entrance continues into the interior, blurring the boundaries of inside and outside and accentuating the connection with the natural environment that is reinforced by the landscaping. Here we are supposed to feel at one with nature, an experience that parallels the way of life and the beliefs of many Native American peoples.

By contrasting and comparing these two buildings, you can see that the conscious choices of the site and the architectural style for a museum send messages about its importance, its function, and the collections housed within.

Use the following questions as a guide to exploring the messages communicated by a museum's exterior architecture:

- Is the building large or small?
- Does a clear path lead to the entrance? What feelings do you experience as you approach? What makes you feel this way?
- Is the entrance obvious? Why or why not? What clues are you given by the architecture, the materials, and the landscaping?
- Is the museum built in an easily identified architectural style? What does that style evoke? If the structure has been modified, how does the new style relate to the old?

Conclusion

In this chapter you have learned to read many types of information that the museum provides to visitors. Some of the messages are visual, such as those given by the museum's location, the architectural style, the scale of the building, and the interior organization of the art. Other messages are stated verbally, such as the museum's policies. Remember that these are all important, and being aware of them lets you concentrate on enjoying the art and interpreting the messages the museum sends to you.

For Your Consideration

Visit a nearby art museum. Describe the museum's site, architectural style, and your approach and entry. What messages are sent to you before you ever enter? Be sure to mention the specific clues.

Visit a nearby art museum but now focus on the museum after you enter the building. What does the ground plan look like and how do you move through that space? What is located in each of the main galleries? Is the art organized chronologically or thematically? Which galleries appear to be the most important? How can you tell?

Research online to find an image of the original Gothic-revival-style facade designed by Calvert Vaux for the Metropolitan Museum of Art. Compare it to the museum's present classically-inspired facade. What do classical and Gothic-revival architecture each bring to mind? What style do you prefer for the museum and why?

CHAPTER 3
Presenting the Art

As you enter the art museum you may wonder how you will find your way around and, more important, how you will ever learn about the many artworks within.

Fortunately, the museum tries to make these tasks easier for you. An information desk or visitor services area is usually located near the entrance, and you can ask questions there and pick up a map or ground plan to learn where the art is located and how it is organized. In most European and American museums, traditionally the art is organized in chronological order according to periods, countries, or artistic movements. The art may also be organized thematically, especially in special exhibitions.

How Museums Display Art

Many museums group art according to chronological periods or cultural or thematic similarities. Yet, how is the art itself displayed? And how does the museum balance the exhibition and the preservation of art?

You've probably noticed that paintings may be framed or unframed and are usually hung on walls, or that sculptures often stand in the middle of the gallery. But what about the physical conditions in the galleries? What is the lighting like? Does the space feel warm or cold? Does the air seem damp or dry? All these factors are carefully controlled so that the works will not be damaged. This is especially true of paintings on wood panel, for wood is much more susceptible to damage from changing conditions. Watercolors, photographs, textiles, manuscripts, and prints and drawings are also extremely fragile. Such delicate works are often displayed in cases with individually-controlled humidity and temperature levels. The lighting tends to be dim, and the works will be displayed for only a limited time according to a strict timetable established by the museum.

Some types of art, such as stone sculpture, are not as affected by interior environmental conditions. Museums have greater freedom in the display of these works, which are often placed out in the open in well-lit galleries. You can usually walk around freestanding sculpture, so be sure to view it from all angles.

Today, displays incorporate newer media such as videos and computers. These technologies may even incorporate the viewer into the art. Temporary works called installation art have also gained popularity in recent times. These works are commissioned from an artist for a particular gallery space and a limited time. Once dismantled, they exist only in the form of documentary evidence, namely, photographs or film.

What the Museum Label Tells You

You will find wall text posted near each piece of art displayed in the galleries. Called the museum label or exhibition label, this information will identify the works. Some-

times an additional wall text accompanies the label and provides history about the work, details about the artist or civilization that produced it, or other relevant background that helps you understand the art and its context.

Although some variation exists, the sample museum label on page 16 explains what is generally included. The label is for a set of portraits of a husband (**Fig. 4**) and a woman holding her infant daughter, Mary, now in the collection of the Worcester Art Museum.

Figure 4 This painting is the companion to another portrait that shows the wife and child of John Freake. Unknown Artist (Active in Boston in the 1670s). "Mr. John Freake" c. 1671–1674. Oil on canvas. 41.5 by 36.75 inches. Worcester Art Museum. Gift of Mr. and Mrs. Albert W. Rice.

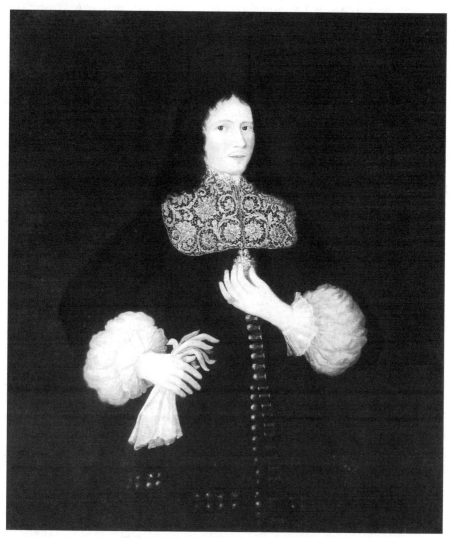

Anonymous artist
American, late 17th century
John Freake
Mrs. Elizabeth Freake and Baby Mary
About 1671–74
American
Oil on Canvas
42 1/2 × 36 3/4 in. (107.9 × 93.4 cm) each
Sarah C. Garver Fund, 1963.135, and Gift of Mr. and Mrs. Albert W.
 Rice, 1963.134.

Name of the Artist

If known, the name of the artist will always be identified. On the label for the Freake family portraits, however the term *anonymous* artist is used because the artist is unknown. Be aware that some artists use pseudonyms instead of their actual names — one such artist was the the Greek-born Spanish painter Domenikos Theotokopoulos (1541–1614), who was known as El Greco (the Greek).

Culture or Nationality and Life Dates of the Artist

In our example, the artist is identified as being American. Since we do not know specifically who painted these portraits, the dates of the artist's birth and death are not given. Yet we can date the paintings to the late 1600s, so we also know that the artist had to be alive at that time as well. If the artist's birth and death dates are known, you will see a date range, usually in parentheses, after the artist's name. If the artist is still living, you will usually see the abbreviation "b." (meaning "born"), followed by a date. If only the date of death is known, you will see "d." (died), followed by a date. If the precise life dates are not known, but evidence suggests that the artist was working during certain years, you might also see the word active or the abbreviation "w." (worked), followed by a date or date range.

Terms Used with Dates

When looking at art in museums or at reproductions in books, you may often see the word *circa* or its abbreviation, *ca.*, meaning "about" or "approximately." For example, the label for the Freake portraits might have read "ca. 1680," indicating that the works were created about the year 1680.

BC and AD Throughout the world, different religious and cultural groups have used varying calendars. But today the Gregorian calendar is most widely used worldwide. First proposed in 1582, the Gregorian calendar was a modification of the earlier Julian calendar, under which the classification of dates as BC or AD was established. The BC/AD system designates the year Jesus of Nazareth (or Jesus Christ) was born as year 1. Therefore, all dates prior to year 1 are labeled BC, the

abbreviation of "before Christ," and those after are AD, the abbreviation of the Latin phrase *anno domini*, or "in the year of our Lord."

However, because not all people adhere to the Christian faith, scholars have developed more secular (nonreligious) labels while still basing the dates on the year 1. They propose replacing BC with BCE (before the common era) and AD with CE (the common era). (Note that there is no year 0 in either labeling system; 1 BC/BCE precedes 1 AD/CE.)

Whichever system is used, remember that for BC/BCE dates, the higher number is the earlier date, because we are moving toward the year 1; for example, 399 BC/BCE is earlier than 300 BC/BCE. When talking about dates with the designation AD/CE, the reverse is true: the earlier date is the one with the lower number. For example, 300 AD/CE is earlier that 399 AD/CE.

Century Many works of art are centuries old. The term *century* is used to designate a period of 100 years. When discussing AD or CE, the first century refers to the years from 1 through 99, the second century indicates 100 through 199, and so on. Therefore, the Freake family portraits date from the 17th century, meaning the 1600s. For BC or BCE dates, the first century ranges from 99 to the year 1, the second century from 199 to 100, and so on.

Title of the Artwork

Artists will sometimes give specific titles to their works. Yet if no original title exists, one may be assigned to the work by those who come in contact with it, such as the owner, an art critic who wrote about it, or even museum staff. The Freake family portraits were painted for a private individual to hang in the home, and no titles were known at the time they were created. The current titles were given later and simply identify the people in the portraits.

Medium

The exact definition of the term *medium* is the material or materials that make up a work of art as well as the techniques used to create it. The museum label usually identifies only the material(s), in this case, oil paint on canvas.

Dimensions

The dimensions, or size, of an artwork are often provided in centimeters as well as in inches and feet. That is because the United States uses a standard of measurement based on inches and feet, but most of the world uses the metric system. Two measurements, the height and the width, are given for two-dimensional objects such as paintings. Looking at the dimensions on the labels of the Freake portraits, you see that each is 42 1/2 inches in height and 36 3/4 inches in width (the metric conversions are given in parentheses). For a three-dimensional object, such as a sculpture or a vase, you will see that three dimensions are always given: height, width, and depth.

How the Museum Acquired the Work

The final information on a museum label indicates how the artwork was acquired. In this case the portrait of John Freake was purchased through the use of a special fund set up in the name of Sarah C. Garver. The other painting was a direct gift from Mr. and Mrs. Albert W. Rice.

The accession number The number that follows the acquisition information is called the accession number (it may also precede the acquisition information). This number gives you specific information about when the artwork was brought into the museum collection. The accession number for the portrait of John Freake is 1963.135, indicating that it was accessioned in 1963 and it was the 135th object to be brought into the museum's collections that year. The other portrait, whose accession number is 1963.134, came into the museum collection that same year and was the 134th object.

The accession number is the way that most museums identify a work in the collection. It allows staff to keep track of each object, whether it is on display, in storage, or on loan to a special exhibition in another museum.

For scholars wanting to research an artwork in the museum's library or look at special museum files on the object, the accession number is critical for identifying the exact work of art. For example, if the museum has two paintings by the same artist or more than one Greek vase from the fifth century BCE, the accession number allows you to easily identify the specific object you want to see or research.

Labels in Special Exhibitions

If you visit a special exhibition at a museum, you may notice that the labels indicate that many of the artworks shown do not belong to that museum but rather to other museums, institutions, or individuals. Museums often borrow works that relate to the theme or subject chosen for the special exhibition. The exhibitions are on view for a relatively short time, usually a few months or a few years. The length will depend on whether the exhibition will travel to other museums around the country or the world. Remember that a museum may give permission to photograph only works in its own collection, not those belonging to another museum or person or one that is on loan to the museum (see Chapter 2, page 9 [Photography]).

Conclusion

As you visit art museums you will see that museums balance protecting and preserving the art while also making your experience a top priority. Most museums strive to help you find your way around by supplying both ground plans indicating the location of the art and labels that tell you a great deal about the works on view. Learning to interpret the information presented to you opens new opportunities for understanding.

For Your Consideration

Visit a museum website and select three different works of art in its collections. Try to choose artworks from varying periods (BC and AD) or mediums — painting, sculpture, textile, print, and so on. Print out the label for each work and compare the information.

Visit a nearby art museum and choose one gallery. Examine the types of art displayed. Determine the medium(s) represented. How are the works arranged? Describe the lighting. Note temperature and humidity levels. Is it clear that the museum has had to make specific choices when balancing the security, exhibition, and preservation of the art?

Research installations by artists such as Kiki Smith, Bill Viola, or Jenny Holzer. How does the artwork interact with the physical space it occupies? Argue for or against the ideas and principles behind installation art.

CHAPTER 4
How Do Museums Know What They Know?

Do you ever wonder how the museum knows so much about the art in its collection? It is largely through the work of museum conservators and curators. As their name implies, conservators safeguard and care for works of art, using technologies to study the materials and techniques used by artists. Curators are specialists in the art of particular periods and cultures. They are involved in on-going research, investigating works already in the collection and carefully studying those that are being considered for acquisition.

But how do curators know what they know? First, they study for many years and gain knowledge through hands-on experience. They tackle the challenge of understanding works of art by relying on provenance, connoisseurship, and technical examination of the work itself.

Provenance

Provenance refers to the records related to an artwork that document its ownership, ideally beginning with its creation date. Yet, gaps often exist because many artworks do not have a consistent, unbroken history of ownership. The earlier an artwork was created, the more likely it is to have an incomplete provenance. As you can imagine, such is often the case for art found by archaeological excavation. The original owners of these objects are often unknown; the provenance thus begins with the date of discovery.

Provenance data includes verification of the known artist or workshop, the history of ownership or documentation from archaeological excavations, any records of sale, exhibition history, and citations in exhibition catalogues or art historical writings about the work. All this information is made available for any artwork that legitimately comes up for sale or donation.

The Rightful Ownership of Art

Recently, many challenges have surfaced concerning rightful ownership of art, especially works that came onto the art market in the mid-20th century. Some are linked to possible forgeries or art illegally taken from a country and later sold. Many of these disputes focus on art that changed hands from 1933 to 1945, the years just prior to and during World War II. During this time, hundreds of artworks owned by Jewish individuals and organizations were confiscated or looted and illegally sold, many to unsuspecting—and some complicit—buyers in both Europe and the United States. In the war's aftermath, many people—including museums and other public institutions—

were reluctant to reveal the gaps in provenance and to identify and locate the rightful owners or, if these had not survived the war, their heirs or next of kin.

Today disputes over rightful ownership of art rage on. Yet, most museums have vowed to meticulously research any works with questionable provenance, especially those acquired during and after the second world war. Museum curators review and verify provenance records and identify those that are false or missing information, with the hope of returning the art to its rightful owners or their heirs. To help with this complicated process, numerous national and international organizations and museums are working toward establishing registries, and many museum websites publicize lists and images of art with questionable provenance.

Connoisseurship

Connoisseurship is the highly developed ability to make determinations about art based on visual study and comparisons with other artworks. A specialist trained in this aspect of analysis is called a *connoisseur*. Relying on an ability to observe visual or formal aspects of a work and in-depth knowledge of art by a particular artist and period, a connoisseur can assist in identifying when, where, and by whom a work of art was made.

Attribution

What if we are unsure which artist created a particular artwork? Connoisseurs, whether curators or independent researchers, often help with attribution, the process of determining the maker or makers of a work of art. Connecting the artist and the artwork may seem straightforward. Sometimes it is. We know, without any doubt, who created many works of art due to one or a combination of the following: the art is signed by the artist with a verifiable signature, it has secure provenance or documentation from its creation to the present, specialists have examined the work thoroughly and agree that it can be attributed to a particular artist, and technical examination of the work connects it to a particular artist.

Attributions remain an important issue because in our society we value the link between art and artist. This value is both intrinsic and extrinsic. For example, we place an intrinsic value on artworks by the Italian artist Leonardo da Vinci (1452–1519) in part because we value his creativity and talent. In addition, an extrinsic value depends on this connection. Paintings by Leonardo are worth huge sums. If we learned that he did not paint a particular work, its monetary value would plummet.

In the case of many early works of art, identifying the artist is not always easy. The Case Study at the end of this chapter presents a specific attribution problem and explores how experts have used connoisseurship as one technique in finding answers to challenging problems.

Technical Examination of Art
and the Role of the Conservator

Adding to the curator's knowledge is important information provided by another group working in museums—conservators. In the past, conservators primarily took care of, or conserved, the art—cleaning, stabilizing, and repairing it as well as recommending the proper conditions for its display or storage. In the 20th century the conservators' role expanded to include technical examination of the art, which has contributed to our understanding of not only the process of creating art but also the changes that may have been made to a particular work. These technical examinations are often time consuming and expensive. Let's take a close-up look at some of these innovative techniques and the new information they contribute to our understanding of art.

Many different types of technical examination are possible. The choice depends first on the object. Next the conservator considers the size of the work and its condition, its format (whether two- or three-dimensional), and the materials used.

Noninvasive methods for examining artworks begin with a close visual examination—detailed records are made and photographs are taken. This process may be enhanced through the use of magnifying glasses, special microscopes, and strong light. The conservators may then use ultraviolet fluorescence, infrared light, and X-ray radiography to help them see the underlying layers of the painting and to determine original rather than later applications of paint, varnish, and the like. These techniques often reveal changes made to the paintings by the original artists or later individuals.

When in-depth information is desired, a more invasive technique might be used. For example, a small sample of material might be removed and analyzed under electron microscopes to determine the chemical content. This vital analysis helps date the object, identify the artist's choice of materials and techniques, and highlights subsequent changes and repairs. It also helps with formulating future conservation plans. Developments in these techniques add to the conservator's ability to provide important information about art and continue to be an exciting and expanding component to the study of art.

Case Study:
Is It a "Rembrandt" or Not?

In 1968 a group of six scholars formed the Rembrandt Research Project (RRP), an undertaking originally supported by the Dutch government. Their primary goal was to publish a catalogue that would represent the definitive corpus, or body of work, of the well-known Dutch artist Rembrandt van Rijn (1606–1669). To accomplish this task, the RRP set out to review all paintings attributed to Rembrandt and to determine which were in fact by him and which were by his students or members of his studio. This task was particularly important because many of the artist's works were under debate.

When examining paintings attributed to Rembrandt in collections worldwide, the RRP scholars decided that each painting was to be classified as either a) definitely by Rembrandt, b) undecided, or c) definitely not by Rembrandt. Within a brief

period the number of paintings attributed to the master shrunk from approximately 1,000 to 300. An outcry exploded in the art world.

One of the contested paintings is *The Polish Rider* (**Fig. 5**), now in the Frick Collection in New York City. The work's provenance dates to 1897, when the scholar Abraham Bredius saw the portrait in a castle in present-day Poland and attributed it to Rembrandt. Steel magnate Henry Clay Frick (1849–1919) bought the painting in 1910, and since then it has been displayed in his former mansion on Fifth Avenue. Yet, even before the RRP's investigation, the work's subject matter was considered unusual—an equestrian rider was not common in 17th-century Dutch art or in Rembrandt's oeuvre (body of work). The RRP rejected the attribution to Rembrandt and reattributed the work to another Dutch artist. However, the Frick Collection's website still identifies the artist as Rembrandt, with the justification that Rembrandt may have intended this work to be a representation of a foreign soldier, which museum curators see as consistent with subject matter in the artist's prints.

Figure 5 Although all parties agree that this work is a 17th-century Dutch painting, they continue to debate what artist created it. © Rembrandt Van Rijn, Dutch (1606–1669). *The Polish Rider.* Canvas 46 × 53-1/8 in. The Frick Collection, New York.

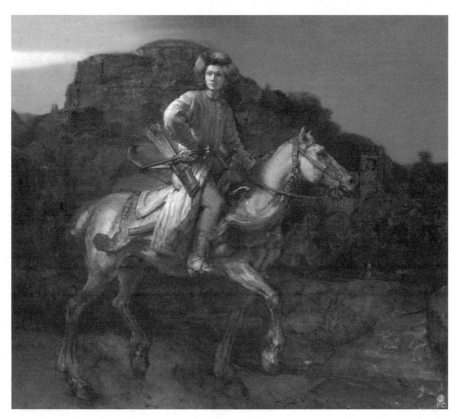

Consider the following questions:

- Beyond considering subject matter, how could paintings attributed to Rembrandt be examined to determine whether they were made by him or not?
- What could technical examination tell us? What could it not tell us?
- Why might people protest if paintings formerly attributed to Rembrandt were reattributed to his students or followers? What difference would that make for the owners of such works?
- Why would the Frick Collection continue to identify *The Polish Rider* as being by Rembrandt? In your opinion, does it really matter whether or not this painting is by Rembrandt? Why or why not?

Conclusion

In this chapter you have learned about how museums and specialized staff members contribute important information about works of art. Curators research the art's provenance, or records of ownership, and they often match a work of art with the artist who created it in a complicated process called attribution. Conservators, too, supply vital background about how an artwork was made, what changes it has endured over time, and how it should be cared for and displayed.

For Your Consideration

What is provenance and why is it such an important issue in the art world?
The Universal Leonardo project, launched in 2005, focuses on the techniques and processes used by Leonardo da Vinci rather than claiming to determine attribution. Why do you think this shift has taken place?

The importance of on-going provenance is underscored by the report of the Association of Art Museum Directors (AAMD) Task Force on the Spoliation of Art during the Nazi/World War II Era (1933–1945), written in June 1998, and the addendum of 2001. Visit the association's website (http://www.aamd.org), click on "Position Papers & Reports" and then on "Report of the AAMD Task Force on Nazi Looted Art, June 4, 1998." What is the AAMD trying to do about some of the issues of rightful ownership? Do you think that museums should be required to go to the effort and expense of continuing to research and publicize art that came into their collections during these years? What are the major points of the addendum dated April 30, 2001? Why do you think this was added?

YOU AND THE ART

CHAPTER **5**

Talking about Art

Art is a visual experience. Describing and analyzing that experience is essential to your study and appreciation of artworks—their significance and their impact. But you're probably wondering how to talk about art. First, ponder a few questions. What do you see when you look at an artwork? How does it make you feel? What does it make you think about? How did the artist make it look the way it does? Now that you have a few questions to start with, let's learn how to describe and analyze what you see.

Formal Analysis

Art historians use several approaches, or methodologies, to study art. Depending on the approach, you will ask different questions about an artwork and explore varied aspects of it. You are about to learn how to carry out a visual, or formal, analysis, an approach that is fundamental to the study of art.

As in any discipline, talking or writing about art requires its own vocabulary. You may know how you feel about an artwork, but putting those feelings into words may present a challenge. In formal analysis, you describe and analyze an artwork's visual qualities. The more you practice formal analysis, the easier it will become. You will also find that your ability to look at art will change—you will soon be able to see more and to better articulate what you see.

First, it's important to understand that art has two major components: form and content. Form refers to the purely visual aspects of art and architecture. These attributes are often called the formal elements. Content refers to the work's subject matter. In addition, art is also distinguished by style and medium. So let's start with the basics and then examine each of these terms in more depth.

The Basics

It often helps to start your visual analysis with the obvious facts. Who made the art? When? Where? What mediums—materials or techniques—did the artist use? You can find much of this information on the museum label, but don't stop there. You'll often learn more by focusing on the artwork itself rather than the text accompanying it.

Artworks are either two dimensional or three dimensional. Two-dimensional art is created on a flat surface called the picture plane. The picture plane is organized into three areas: foreground, middle ground, and background. Examples of two-dimensional art include painting, drawing, and prints. Three-dimensional art encompasses sculpture, architecture, ceramics, and any object that takes up space in height, width, and depth.

Next, look at the work's overall format (general shape or structure). Is it primarily vertical, horizontal, or on the diagonal? If you are looking at sculpture, does the form open up and extend into space, or does it look as if it is tightly compact or closing?

Your Viewpoint

Your relationship to the art is an important factor in your experience of it. Consider how you physically relate to the work, especially in relation to its size. You can relate to a work that has a human scale in a more direct and personal way. Works that are life-sized encourage you to feel as if you are looking at an actual person or object. Those that are monumental may make you feel dwarfed and intimidated. Artworks that are small may persuade you to examine them close up.

Form

Form consists of the many visual aspects of an artwork, including line, color, texture, spatial qualities (mass, volume, and space), and composition.

Line

Line is a mark left on a surface, such as those made by drawing or painting. Line or outline can also be used to define the boundaries of a shape. Artists use line to achieve certain effects, whether to draw your eye across a surface or perhaps to move it around in a random path. Lines can also be quite expressive. Each of the lines below (**Fig. 6**) leads your eye in a particular way and also causes an emotional effect. Which

Figure 6

one gives you more of a sense of calm? Which seems stronger? Which seems more energetic?

Sightlines are imaginary lines suggested by the artist. Have you ever noticed how, in a painting or sculpture of people, their gazes direct your eye to different areas of the work? How does it affect you when the figures are looking not at each other but at you? Or off into space or with downturned eyes?

Color

Color has three major components: hue, value, and intensity. *Hue* is what you think of when you use the names of various colors. Six basic hues, or colors, make up the visible spectrum. These are grouped into primary and secondary colors. The primary colors are red, yellow, and blue; the secondary colors are orange, green, and purple. Colors may also be grouped into warm colors (red, yellow, orange) and cool colors (blue, green, purple). Value describes the visual degree of lightness or darkness. Dark blue, for example, has a darker or deeper value than light blue. *Intensity*, or saturation, describes the degree of perceived purity of the color. A bright yellow would be described as being an intense, or a highly saturated, yellow. A dull yellow would have a low degree of intensity or saturation.

Texture

Texture refers to the surface quality of a material, such as *smooth*, *rough*, *shiny*, or *dull*. In art, texture may be *actual* or *perceived*. A stone sculpture with a rough surface reveals the actual (tactile) texture of the material. In two-dimensional works, artists can create a sense of texture that our eyes perceive—we "read" the imaginary surface of the object represented by the artist.

Mass, Volume, and Space

Mass is matter, and every physical object has mass and takes up space. Volume is closely related to mass; it is the size or the dimensions of an object. Space is the area that contains, or is defined by, an object. When we look at sculpture, architecture, or other three-dimensional objects, we have a sense of their actual mass and volume as well as the space taken up or defined by them.

Artists also represent these qualities in two dimensions. Paintings or drawings may have a perceived sense of mass, volume, and space. On a two-dimensional surface, the artist can make us believe that we see actual objects in space. How do they create that perception?

Creating believable space Artists use several pictorial devices, or conventions, to make figures and objects represented on a two-dimensional surface appear to have mass and volume and exist in space.

- Dark and light — darker areas tend to recede in space and appear farther away, and lighter areas appear to come forward and seem closer.

- Foreshortening — objects shown on an angle or perpendicular to the two-dimensional picture plane make us believe they exist and recede in space.
- Overlapping — an object partially covered by another appears to be behind the one in front of it.
- Diminishing size — smaller objects look farther away than larger ones.

Putting perspective in perspective Artists use several types of perspective to create the illusion of spatial recession, also called pictorial depth.

- Vertical perspective — An object placed above another is meant to be read as being farther back (see **Fig. 7**).
- Atmospheric, or aerial, perspective — Artists often show distant objects in bluish gray tones, which makes our eyes perceive them as being farther away (see **Fig. 8**).
- Linear, or one-point, perspective — Most common in Western artworks, this type of perspective was first developed in Italy in the early 1400s. It uses imaginary lines called orthogonals that are drawn back into space from the object and converge at a vanishing point.
- Two-point perspective — Similar to linear perspective, in this system the orthogonals go off in two directions and converge at two different vanishing points.
- Reverse perspective — In this visual tradition, popular in Byzantine art, orthogonals do not go back into space and meet. Instead they come out from the picture plane and theoretically meet in front of the viewer's eyes.

Composition

Composition refers to the way that the formal elements are organized. Compositions may be symmetrical or asymmetrical, and they may or may not be balanced. Drawing an imaginary line down the center of an artwork, if each side is similar, the work is symmetrical. If each side is significantly different, the work is asymmetrical. If both sides are exactly the same, the work has bilateral symmetry. A work appears balanced if elements on one side have the same visual "weight" as those on the other. A balanced work may be either symmetrical or asymmetrical.

Content

As you study art, you will likely want to know what the works are about. Content refers to the work's subject matter. What does the artwork show? Can you recognize the subject? Does the work seem to tell a story, or narrative? Sometimes the content is obvious, but sometimes it is not. The museum label will include the work's title, giving you a hint about its subject. Learning about a work's content may require additional research. Specialized in-depth study of subject matter is called iconography, which is discussed in Chapter 7 along with iconology, the study of the meaning of an artwork within its context.

Figure 7 This Indian painting shows vertical perspective—as your eye moves upward, you are meant to "read" the higher objects as being farther back in space. Kavala (active 1778–1820), *Nobleman Hunting a Boar*, 1810–1815. India, Deogarh, Rajasthan state. Ink and colors on paper. Gift of Gursharan and Elvira Sidhu, 1991. 253. © Asian Art Museum of San Francisco. Used by permission.

Figure 8 In this representational painting, the artist uses aerial perspective to create pictorial depth. Leonardo da Vinci, Florentine, 1452–1519. *Ginevra de'Benci*, 1474. Oil on panel, H. 15-1/8 × W. 14-1/2 in. The National Gallery of Art, Washington, D.C.

Style

Broadly speaking, style is the combination of form and content that makes a work distinct. Style may be linked to a historical period, a specific culture, or a particular artist or group of artists. The root of the word style helps us understand its meaning. It comes from the Latin word *stylus*, a writing implement. And indeed style is very much like handwriting—it is unique to a specific period, culture, or individual.

Why is style important? Style helps you make intelligent guesses, or hypotheses, about artworks based on the visual evidence. Remember that many artworks lack signatures, so the artist, date, or place of creation is often unknown. By analyzing the

form and content of a work, you can then arrive at an educated guess about when and where it was made, who might have made it, and sometimes even why it was created.

Helpful Terms for Discussing Style

Artists worldwide and throughout history have worked in an amazing range of styles. The style of an artwork often strongly impacts the viewer. Art that attempts to evoke a strong emotional reaction in the viewer is described as having an *expressionistic* style.

Representational, abstract, and nonrepresentational These three categories describe how the artist has chosen to depict the content or subject matter. *Representational* art shows something recognizable. *Abstract* art exaggerates certain aspects of the person or object, but the subject is still identifiable. *Nonrepresentational* (also called nonobjective) art does not intend to represent a recognizable person or object.

Linear and painterly If an artist emphasizes line or outline to create and define an artwork, the art is described as being *linear*. When modeling or shading dominates the art, it is described as being *painterly*.

Real and ideal *Realistic* art tries to capture visually the way an object or person looks in reality. Sometimes the term *naturalistic* is also used to describe art that attempts to portray subject matter the way it looks in nature. An *idealistic* artwork tries to present what a particular artist or culture considers the standard of perfection, or ideal, of an object or person. Remember that the concept of the ideal varies depending on the historical period and culture in which it developed.

Medium

Style is also closely linked to medium (the materials and techniques chosen by the artist). The range of mediums is astounding—from paint, ink, and pencils to stone, bricks, and wood to clay, metal, and glass. With each new generation of artists, never-before-used mediums appear, such as photographs in the 19th century and videos and computers in the 20th century. You'll often find that artists send important messages about the meaning and intent of the artwork through the medium they choose.

Case Study:
Practicing Visual Analysis

One of the traditional ways of developing your ability to recognize different visual characteristics of art—the form and the content—is by comparing two works. Let's begin with two strikingly different portraits: Leonardo da Vinci's *Ginevra de'Benci* (**Fig. 8**), from 1474, and *Les Demoiselles d'Avignon* (**Fig. 9**), painted by Pablo Picasso in 1907. The former is an individual portrait of a young Italian woman

Figure 9 In this abstract painting, life-sized women confront the viewer. Pablo Picasso, *Les Desmoiselles d'Avignon*, 1907. Oil on canvas, 8′ × 7′ 8″ (2.43 × 2.33 m). The Museum of Modern Art, New York, USA/The Bridgeman Art Library, © 2007 Estate of Pablo Picasso/Artist's Rights Society (ARS), New York.

emphasizing her nobility; the latter is a group portrait of *demoiselles*, meaning "prostitutes," in Avignon, the red-light district in Barcelona, Spain. Notice that Leonardo's painting is small and intimate and that the artist only depicts the woman's head and shoulders as she looks demurely out at the viewer. He concentrates on her stylized hair and clothing, paying careful attention to the background. Picasso depicts the women in full length and nude, starkly confronting the viewer. The artist abstracts the figures, and the background is not essential.

Consider the effect that each of these paintings has on you. Then review the components of a visual or formal analysis and write a brief essay comparing and contrasting the visual elements of these two paintings and ultimately, the impact on you, the viewer.

Conclusion

Continue to look at art and practice talking about a wide variety of artworks. You will find that the basic terminology for a visual analysis that you have learned in this chapter will become more natural to you. Soon you will find that you see more and more each time you look at art.

For Your Consideration

Look closely look at *The Polish Rider*, attributed to Rembrandt (see Fig. 4, page 23). What devices of perspective does the artist use to make us believe that the figures exist in space?

Visit a nearby museum (or refer to images from a text or website) and choose two paintings that each use a different system of perspective. Discuss the system each artist chose and how that system organizes space. What do the artists want you to believe? How do they achieve that goal? What are the opportunities and limitations of each system?

Visit a museum and select two paintings or two sculptures that differ dramatically in size. Consider the medium, the possible functions, and the way each makes you think and feel. Then discuss how the size of each work impacts your experience and your understanding of it.

CHAPTER 6
Writing about Art

Writing about art can be an enjoyable and enlightening experience. It needn't be one that intimidates or worries you. As you learned in the last chapter, a useful set of terms allows you to put into words your visual analysis of an artwork. The guidelines in this chapter will help you prepare and write an introductory-level assignment. They can be used for more complex assignments as well.

Selecting an Artwork for Your Paper

In your art history or studio art class, you will likely be required to write a paper or essay about a work of art. How do you go about choosing something to write about? First, make sure that the work you select falls within the guidelines of your assignment; for example, the art may need to be from a certain time, country, culture, or artist.

Next, follow your gut—choose art that makes you stop and want to look at it. What appeals to you? Do you like two-dimensional or three-dimensional art? Do you enjoy ancient art, art of the Italian Renaissance, Native American art, or contemporary art? Do you like to be able to look at a work and immediately understand what it is about? Or are you more interested in color, texture, or other formal elements? Make sure that you are visually drawn to the work and that it has a profound impact on you. You will be spending a lot of time examining and reading about it, so picking something that interests you is vital.

Museum Collections

When selecting a work to write about, find out whether it is part of the museum's permanent collection or a special exhibition. That will determine how long the artwork will be on display as well as the way in which it is displayed.

The Permanent Collection

The permanent collection comprises art and artifacts owned by the museum. Works on display are usually those that the museum curators consider to be the best examples in the collection. Because of space limitations, many museums are unable to display everything they own. In addition, some artworks cannot be exhibited regularly because of their fragility or sensitivity to light and humidity levels. Still other works may be on loan to other museums for special exhibitions.

Artworks in need of conservation or repair, or those under technical examination, are also not on view but are kept in conservation labs either within the museum itself or at a separate facility. You may notice a sign in place of an object telling you

that the work has been removed for conservation or that is on loan for a special exhibition.

Special Exhibitions

Special exhibitions are temporary displays, often traveling to a few museums. If you select an artwork from such a short-term exhibition, be sure to note the show's dates so that you will be certain of having access to the work during your project. These shows usually focus on a particular artist or a theme in art or the artist's works. Museums often develop special exhibitions from their own collections, bringing out artworks not regularly seen, or by gathering together works that are usually scattered in museums and private collections throughout the world.

What Type of Art to Choose for Your Paper

Art can be classified in different ways. One of the broad categories is the type of art, which is determined by the medium. Medium refers to the material or materials and the technique or process used in making the art.

In addition, Western art historians have traditionally promoted a hierarchy of the arts, dividing them into "major" and "minor" categories. The major arts are painting, sculpture, and architecture. Examples of the so-called minor arts include the graphic arts and decorative arts, such as textiles, furniture, pottery, and ceramics. Many scholars are currently challenging this traditional hierarchy because it assumes a "high" and "low" judgment about art. But for now the distinction between major and minor arts continues.

Painting

The two-dimensional art form known as *painting* is traditionally created by applying paints, such as tempera, oil, or acrylic, onto a flat surface like wood panel, linen, or canvas. Paintings within manuscripts made of animal skin, a technique called *illumination* that was popular during the Middle Ages and the early Renaissance, is also an important art form. In *frescos*, the artist mixes the pigment (color) into the plaster and paints directly on the wall; when the plaster dries, the painting becomes a permanent part of the wall.

Sculpture

Sculpture is three dimensional, meaning that it has height, width, and depth. We often talk about sculpture as being freestanding, in the round, or relief. *Freestanding* sculpture is worked on all sides so that the viewer must walk around it to experience it fully. *Relief* sculpture still forms part of the material from which it is carved or cast. If the carving is fairly flat and does not protrude from the surface, it is called *low relief* or *bas-relief*. If it protrudes more from the background material, it is called *high relief*.

Sculpture can be made of almost any material, and the material often determines the techniques used by the artist. Traditionally, stone sculpture is created by carving or taking away pieces. Because the artist removes, or reduces, the original material, the process is called *reductive*. An *additive* process occurs when the material is malleable or able to be shaped or molded, such as clay.

Architecture

Although we think about architecture as being only buildings, the term includes how we conceive of and organize space. Like sculpture, architecture also exists in three dimensions. However, because you have to move through the space, the fourth dimension of time needs to be added to the discussion of architecture. Several American museums contain reconstructed architectural works, such as the ancient Egyptian Temple of Dendur, originally built about 15 BCE and reconstructed in the Metropolitan Museum of Art in New York City, and the Chicago Stock Exchange Trading Room by Louis Sullivan (1856–1924) and Dankmar Adler (1844–1900), reconstructed in 1976–77 at the Art Institute of Chicago. Such reconstructions provide the opportunity to experience firsthand the particular ambience and space of important architecture from distant countries or historical periods.

Graphic Arts

The graphic arts are usually created by adding lines or strokes to a flat surface such as paper. These two-dimensional artworks include prints, drawings, photographs, and watercolors. Artists can choose from a wide variety of drawing materials, traditionally pencil or graphite, charcoal, ink, and crayon. To develop their skills, artists often complete drawings in their art training. They also use drawings to work out ideas for work in another medium, perhaps a painting or sculpture. These are called preparatory sketches. All printmaking processes are distinguished by their ability to produce multiple originals. Among the wide array of printmaking techniques are woodcuts, engravings, etchings, drypoint, and lithography.

Decorative Arts

Art historians have traditionally used the term decorative arts to refer to art objects created by craftspeople for a particular function or as ornamentation for an interior. These include furniture; ceramic, glass, or wooden objects; and textiles like rugs and quilts.

Ephemeral Arts

Another category comprises works created for a specific event or purpose but without the intention that they would last. These ephemeral arts include art created for festivals, processions, or plays as well as performance art, installations, video art, and earthworks, often called site-specific art. One example of art made for a specific loca-

Figure 10 Fluttering in the wind for only 15 days, *The Gates* is one of many site-specific installations by Christo and Jeanne-Claude. "The Gates, Central Park, New York City, 1979–2005." Christo and Jeanne-Claude. Photo: Wolfgang Volz, copyright © 2005 Christo.

tion and with a limited "life" is *The Gates* (**Fig. 10**), a series of gatelike structures hung with orange fabric and erected over paths in New York City's Central Park. Envisioned and installed in February 2005 by artists Christo and Jeanne-Claude and their team, the work was on view for only 15 days and exists today solely as documentary photographs, videos, and drawings.

The Writing Process

Like any process, selecting an artwork and writing about it require several steps. To be successful, be sure to complete each step and ask questions during the process. Remember that many professors will meet with you to discuss your paper or read drafts and provide comments. Many colleges also offer tutors or writing centers. Writing becomes easier with practice—just be sure to allow enough time to reflect on your assignment and then to write and revise.

Understand the Assignment

Before you begin writing, be sure that you have thoroughly read and clearly understand the assignment. Art history papers vary depending on the course level. In an introductory survey class, you may be asked to examine a work of art and talk about how the artist organized the composition or how the work impacts the viewer emotionally. For a more specialized class, the professor may ask you to compare and contrast two artworks. In advanced art history seminars, you will be expected to conduct in-depth research and sophisticated analysis of broad or complex topics.

Parts of the Paper

Many writers like to start the writing process with an outline and then gradually expand these main points. The following three basic components make up any writing assignment:

The introduction or thesis Begin with a brief introduction to your topic, which is often called the thesis statement. You should briefly state your thesis, indicate your viewpoint on this topic, and make a general statement of what you will cover.

The "body" This section will be the longest—it contains your argument and a presentation of the evidence you collected to support it. You might present visual evidence from your observations of the art, or you could focus on textual evidence that challenges the way a work of art has been interpreted in the past. Many papers for introductory art history courses do not require research. However, if you do use any outside sources—whether direct quotations or ideas from another author—you must cite them. Be sure to ask your professor about the accepted format for footnotes or end notes as well as for the bibliography or list of sources, including websites.

The conclusion In this last section, briefly remind the reader of your original thesis and then state the conclusions you arrived at after your review of the evidence.

Visual Evidence and Sketches

You may want, or be required, to include visual evidence to support your thesis. This could consist of sketches, a postcard of the artwork from the museum shop, a copy of the work from a book, or even a photograph of the object (on obtaining permission to photograph in a museum, see Chapter 2).

Don't be afraid to draw the object. Sketching makes you look more closely at the art, and suddenly you see things you had missed before. It becomes a simple tool to help you train your eye and learn to examine art more carefully. Making visual records will aid you tremendously when it's time to write. Sketches and notes taken while viewing art can provide a useful visual reminder. Jot down your initial impressions to help you recall important aspects you might otherwise forget.

Proofing Your Paper

Once you've put your ideas onto paper, thoroughly read through your draft. Is your thesis clear? Do you provide evidence to investigate and to prove your thesis? Finally, in your conclusion, do you restate your thesis? Have you included your major conclusions about that topic? And, most important, have you used footnotes or end notes to cite all the direct quotes and ideas you borrowed from others?

The best advice for preparing a high-quality paper is to revise and then revise again. One way to make sure that your paper reads easily and smoothly is to read it out loud. Does each sentence make sense? Do the ideas flow logically toward a conclusion? Also be sure to check for proper grammar, punctuation, and spelling. Checking these important concerns contributes greatly to the quality of your paper.

Conclusion

Writing about art can become as natural an activity as looking at art—it just takes practice. Remember to follow the assignment guidelines carefully and choose a work that "calls" to you. Start the assignment well in advance to allow time for reflection, writing, and revision. Then follow the basic steps of the writing process and seek assistance from your professor.

For Your Consideration

Write a brief essay identifying your favorite work of art in a nearby museum and discuss why it appeals to you. Be sure to identify the work completely (see the museum label), including the type of art (painting, photography, video, etc.), the medium (material and techniques), scale, and a brief visual analysis. Discuss its impact on you and explain whether it falls into the so-called major or minor art category.

Search the website of the National Gallery of Art (www.nga.gov) for information on the 1995–96 special exhibition titled *Vermeer*. Write a brief essay

explaining why this exhibition was so important. You will also need to research the artist and a number of his surviving works.

Identify a special exhibition at a nearby art museum that you can visit in person (or at least on the Web) and write a critical review of it. Be sure to include the show's title and theme, the type of art shown, the museum's stated goals, and your opinion of whether or not the show meets those goals.

CHAPTER 7
What Is the Meaning of the Art?

Think of a work of art that you consider beautiful. Why is it beautiful to you? Do others also find it beautiful? The question of whether or not something is beautiful is a complex and highly personal one. And whether or not beauty is even a concern in the study of art has become a surprisingly thorny issue. In the past, art historians placed great emphasis on classifying art as beautiful, but such categorizations proved to be too subjective. Scholars have thus developed more objective methods for interpeting art, including the examination of subject matter (iconography) and context (iconology).

Aesthetics: The Study of What Is Beautiful

The study and appreciation of what is beautiful is called *aesthetics*, from the Greek word *aisthetikos*, meaning "perceiver" or "sensitive." Discussions about beauty have had a long history, and aesthetics once ranked high in the study of art. Recently, however, the importance and validity of aesthetics have been challenged. Many art history texts avoid the term *beautiful* when discussing art. Why? Reasons include shifts in society and values and in the ways we study art (methodology). Let's take a closer look at the issue, and you can determine your own opinions.

Is Beauty in the Eye of the Beholder?

In the 18th century, German philosophers established a field of study focusing on beauty, taste, and the sublime. This trend continued into the 19th and early 20th centuries as an important part of the study of art. Yet in the mid-20th century, major challenges to these methodologies arose. Discussions about aesthetics, formal analysis, and iconography were overshadowed by increased interest in psychoanalytic theories, social and cultural contexts, gender theory, and other approaches that paralleled changes in such disciplines as literature and history.

Debates about aesthetics raised several questions. What if agreement on what is beautiful cannot be reached? How can a small group of people, the aesthetes (those who study and understand aesthetics), make that decision for everyone? This inquiry leads us to the core of the issue: Is there a universal concept of what is beautiful? And does this universal concept exist throughout time and across cultures? If you could assemble people from different historical periods, cultures, religions, ethnicities, genders, and values, do you think they would all agree on what was beautiful?

If you answer yes, then you believe that the appreciation of beauty is a transhistorical absolute, meaning that if an artwork is truly beautiful, the appreciation of that beauty cuts across all historical periods and cultures. Yet, many argue that beauty is in the eye of the beholder. If that is so, then an individual's idea of beauty may be based on the time in which they live, their gender, and their culture, among other

factors. According to this viewpoint, the concept and the appreciation of what is beautiful change since they are bound within each person and are thus influenced by personal life experiences.

Iconography

Iconography is the in-depth study of subject matter. It goes far beyond identifying what we see. The term comes from two Greek words, *eikon* (image) and *graphe* (writing). This definition suggests that by viewing or "reading" images in art, we can find meaning. With iconographic study, you examine the subject matter in relation to how it has been presented by other artists in other periods and cultures. You also look at the symbols or attributes in the work and try to detect their meaning. *Symbols* are images that represent other things or ideas, and *attributes* are symbolic objects that help us identify a deity, saint, or person.

Iconology

Iconology is closely related to iconography, but it includes the context in which the art was created. When we move from iconography to iconology, we delve into the social, religious, and cultural context of a work in much more depth. This examination requires a thorough understanding of the historical era in which the work was made, including social conditions, morals and values, traditions, beliefs, and customs. All these factors influence artists, who then incorporate subtle meanings into their works that, for the uneducated observer, are impossible to know.

Case Study: Methodology—Description, Iconography, and Iconology

Now let's put into practice the approaches we learned in this chapter. This case study examines one painting from three different perspectives: a visual description of what you see; a brief iconographic analysis, or the meaning of what you see; and a discussion of the iconology, a more extensive study of the cultural and religious context at the time the work was made.

Description

Let's describe what we see in *The Annunciation Triptych* (**Fig. 11**), an oil painting on wood panel created in present-day Belgium about 1425 by Northern Renaissance artist Robert Campin (active 1406–d. 1444) and an assistant in his workshop. Its format is a *triptych*, meaning that it is made up of three panels. Notice that the artist has placed the most important scene in the largest central panel. There you see an interior, a modest domestic setting, and the two principal figures placed in the foreground—a woman on the right reading a book and, on the left, a kneeling, winged man dressed in a white robe and looking at the woman. A figure on a cross enters through the

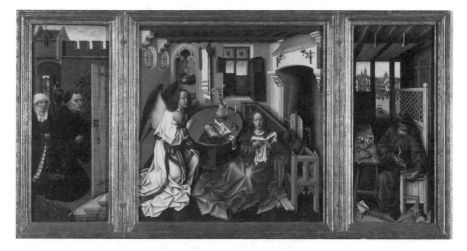

Figure 11 A closer look at the symbols in this painting reveals the subtle meanings it contains. Robert Campin (active by 1406–died 1444), *The Annunciation.* Triptych. Oil on wood. Central panel: H. 25-1/4 in. × W. 24-7/8 in. (64.1 × 63.2 cm). Each wing: H. 25-3/8 in. × W. 10-3/4 in. (64.5 × 27.3 cm). The Metropolitan Museum of Art, The Cloisters Collection, 1956. (56.70) Photograph © 1996 The Metropolitan Museum of Art.

window (in the upper left). The artist was clearly interested in showing details of the interior space, including a fireplace, a table on which sits a vase holding a lily, a book, and a snuffed-out candle. On the left panel, a man and woman are shown kneeling in the foreground; on the right panel an old man, a carpenter, builds a mousetrap.

Iconography

As you may suspect, all these elements have greater meaning. Artists often use symbols to tell a story, usually a religious one, and in art historical study you learn what many of these symbols mean. In this work, the artist recounts the Annunciation, a story from the Christian Bible. The winged man represents the angel Gabriel who announced to Mary that, although she is a virgin, she will bear a child. The lily symbolizes Mary's purity. The figure on the cross symbolizes the crucified Jesus Christ. The figures in the left panel are portraits of the donors. We can deduce that because artists at this time often included portraits of the people who commissioned or donated the work. In the right panel is a rare appearance of Joseph, the husband of Mary and the earthly father of Jesus. We can infer his identity because, in the Bible, Joseph is identified as being a carpenter.

Iconology

This aspect of our study is the most complex and involves examining and explaining the painting within the cultural context in which it was created. To understand the

deeper meaning, you would research and study the religious and historical trends within the early 15th century. Your research would include how the domestic interior shown paralleled the devotional Christian literature at that time. You would likely discover that Mary's pose of being seated on the floor indicates her humility and stresses her feminine virtue. You might investigate why Joseph is portrayed here and what the significance is of the mousetrap. You would then learn of the increasing popularity of the cult of Saint Joseph and ascertain that the mousetrap might be a symbol for catching Satan.

Conclusion

Scholars, students, and critics interpret and find meaning in art in diverse ways. We call these approaches methodologies, and the method you choose dictates the questions you will ask and, ultimately, the answers you will find. Aesthetics, or the study of beauty, was once a highly regarded approach. Today art historians focus on iconography and iconology to understand artworks and their role within a society.

For Your Consideration

Select a painting or a sculpture that you consider to be beautiful. Write a brief essay responding to the question, What is beauty? Give specific examples and reasons and identify in visual terms what you find beautiful about the work.

Choose an artwork and use it as your visual evidence for a discussion titled "Beauty: Past, Present, and Future." Try to state the issues of whether or not beauty is transhistorical and advocate for the work you selected to be accepted or rejected as an example of beauty for all ages.

With the assistance of your professor, select a work of art from the Northern or Italian Renaissance. Observe the work closely, describe what you see, and then complete the necessary research for a complete iconographic analysis.

CHAPTER 8
Art and Its Context

Art museums serve many vital, positive functions. They care for art, study it, educate others about it, and make it accessible to diverse people.

Museums expose you to works you might otherwise never see. But many artworks were created for a specific place, and removing them from their original setting changes their physical and cultural context. It may dramatically alter not only your experience of them but also their intended meaning. Many works were also made to serve a particular purpose—whether cultural, civic, religious, or personal. Therefore, when you look at art in a museum, consider where it would have been located originally and how it might have functioned within that society or culture.

Changing Places, Changing Meanings

When a work remains in its original location, we say that it is *in situ*. When art is no longer in situ, its meaning may be lost or changed significantly. Many artworks cannot be fully appreciated or understood without information about the context within which they were made and functioned. In some museums, wall labels provide background to help you learn where an artwork came from and what it did or represented. But many times you will have to discover on your own the significance of the artworks you encounter.

Let's consider a sculpture of a human-headed winged lion, called a *lamassu*, that is currently in the Metropolitan Museum of Art in New York City (**Fig. 12**). This composite being is made up of the head of a man wearing the headdress of a god, a body with features of a lion and a bull, the wings of an eagle, and five legs. Since such an amalgamation of creatures is unfamiliar to most modern Western viewers, you may not be able to understand the meaning of this sculpture. However, what you may be able to share with the original creators and viewers is the impact of its size. Standing more than 10 feet tall, the *Lamassu* towers over people and impresses you with its overwhelming height and strong physical presence.

But imagine the *Lamassu* in situ, forming part of the gateway to the ceremonial entrance of a great ancient palace. Now you begin to recapture more of its intended impact. When created about the 9th century BCE for the palace of an Assyrian king, you would have understood the *Lamassu* to be a protector of the king's palaces and throne rooms.

Art Created without a Specific Location in Mind

Many artworks were not made for a particular place. Such is true of paintings created by 17th-century Dutch artists that were destined for the open market. Although intended to be hung in a home, these works, including many landscapes, were not cre-

Figure 12 Designed to intimidate and awe the viewer the five-legged *Lamassu* is both stationary and in motion. Human-headed winged bull and winged lion (lamassu). Alabaster (ypsum); Gateway support from the Palace of Ashurnasirpal II (ruled 883–859 BCE). Limestone. H: 10′. L: 9′ 1″. The Metropolitan Museum of Art, Gift of John D. Rockefeller, Jr., 1932. (32.143.2) Photography © 1981 The Metropolitan Museum of Art.

ated for a specific patron (client) and their meaning was not influenced by where they were displayed. After the 19th century, as artists began creating more works for the open market, the physical context became less significant. Artists today still receive commissions from patrons to create works for specific sites, but many produce artworks as personal expressions (although often with the hope of an eventual sale).

Advantages to Changing Art's Physical Context

Let's push the issue of the importance of an object's physical context a little further. What if placing a work within an art museum didn't take away from its meaning? Instead, what if doing so bestowed status and enhanced its importance and significance? Artist Marcel Duchamp (1887–1968) considered just such ideas when he created his sculpture called *Fountain* (**Fig. 13**) in 1917.

What is the first thing you notice about this object? Would you consider it an artwork? The sculpture jolted the art world when it was first exhibited. To create it, Duchamp purchased a urinal at the J. L. Mott Iron Works, signed it "R. Mutt," titled it *Fountain*, and submitted it as his entry to the first exhibition of the American Society of Independent Artists.

Duchamp altered nothing about this mass-produced object except to turn it upside down and add a signature. But by doing so, he changed the way people viewed and thought about this ordinary item. He challenged longstanding ideas of beauty in art as well as the very definition of art itself. Duchamp argued that the context—the exhibition—bestowed meaning on this object, which he declared was now art. Do you agree? The jury of the American Society of Independent Artists rejected *Fountain*, but their decision did not prevent this work from being seen and impacting the art world. Duchamp proceeded to make several versions by purchasing more urinals and signing them "R. Mutt/1917."

Duchamp's challenge opened the gates for other artists questioning not only what art could be but also who determined what was considered beautiful. Since the early 20th century, artists have explored myriad "nontraditional" art mediums, from found and mass-produced objects like those used by Duchamp to new technologies such as videos, computers, and light-emitting diodes. Artists now determine what art is, and whether the work is considered beautiful is often irrelevant. And although controversy continues to swirl around *Fountain*, many consider it to be a groundbreaking work in the history of art. What do you think?

Conclusion

Displaying an artwork in a museum affects your experience of it. You may find it more difficult to reconstruct the work's original intention or meaning, or the museum setting may confer a new meaning on the work. You should view each artwork critically and consider why it was created and how the physical context impacts its meaning. Doing so will strengthen and deepen your understanding of art history and the role art has played in cultures worldwide.

Fountain by R. Mutt Photograph by Alfred Stieglitz

THE EXHIBIT REFUSED BY THE INDEPENDENTS

Figure 13 Using a ready-made object, Duchamp challenged ideas of what is art and what is beautiful. Marcel Duchamp, (American, 1887–1968), *The Fountain*, 1917. Fountain by R. Mutt. Glazed sanitary china with black paint. Photograph by Alfred Stieglitz in "The Blind Man, no. 2, May 1917; original lost. © Philadelphia Museum of Art: The Louise and Walter Arensberg Collection. 1998–74–1. © 2007 Artist's Rights Society (ARS), New York/ADAGP, Paris/Estate of Marcel Duchamp.

For Your Consideration

Select an artwork in a museum that appears to have been created for another physical context. (You may need some guidance from your professor.) Research the work and determine what that original context was. Can you reconstruct

the work's original impact and meaning? What positive or negative effect does the museum setting have on the work?

Many modern and contemporary artworks were not created for a specific location. Despite that, do you think their current location affects their meaning? How?

Visit the website of the Metropolitan Museum of Art in New York (www.met-museum.org). Click on the Permanent Collection link and then Ancient Near Eastern Art link, on whose opening page you will see a reconstruction of the gateway for the palace of King Ashurnasirpal II in Assyria. Notice the five-legged *lamassu*, shown from two vantage points. Visualize approaching the sculpture from the front, where only its two strong legs in a stationary pose are visible. The three-quarter view changes your impression—now the legs are shown in motion. What messages might the king have wanted to send to visitors and why?

YOU, THE ART, AND THE MUSEUM

CHAPTER 9
Ongoing Challenges

Many challenging questions swirl around the study and the display of art. As you learned in the previous chapter, one of the core issues seems basic: What is art? Yet this complex question demands that you have a concrete definition of art.

Which Art Is Important?

In Chapter 6 you learned about the long-established hierarchies in the art world that elevate the so-called major arts over the minor arts. You'll recall that traditionally the major arts include painting, sculpture, and architecture, and the minor arts include textiles, metalwork, glassmaking, and other decorative arts.

Many decorative arts pieces were not created as *ars gratia artis*. This Latin phrase means "art for the sake of art," that is, art created for purely aesthetic or artistic reasons rather than practical ones. Because these works were made primarily to serve a function as well as to be beautiful, they are generally placed in the minor arts category. But is the distinction between the categories of major and minor arts valid?

Let's look at the types of art that past societies considered important. The Anglo Saxons, an early people who migrated to what is now England in the fifth and sixth centuries, created sophisticated metalwork. Look at the *Great Square-Headed Brooch* (**Fig. 14**) from the sixth century. Notice how it is covered with lavish surface decoration of various animal motifs such as animal heads with open jaws. Surviving Anglo-Saxon texts attest to the fine work, and from the surviving pieces in gold, silver, and bronze it is evident that Anglo-Saxon metalworkers were highly skilled craftspeople with a sophisticated aesthetic sense. If the Anglo-Saxon peoples considered metalworking one of their most valued art forms, why shouldn't we place it in the major arts category?

Indeed many scholars, curators, and museum officials are reexamining the notion of major versus minor arts and are questioning the judgments of "high" and "low" art. In addition, they are reconsidering how the arts of non-Western cultures are displayed and explained to museum-goers. These reevaluations often result in the reconfiguration of galleries and exhibition spaces, which can be a costly undertaking for many museums.

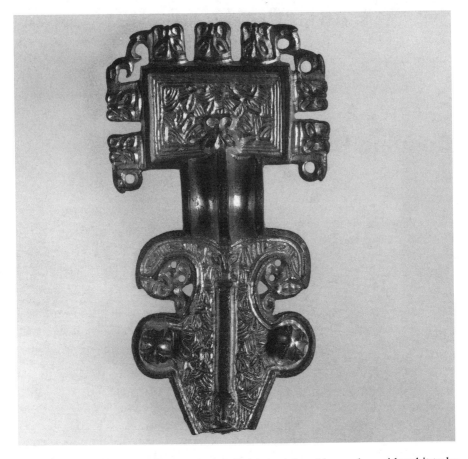

Figure 14 Anglo-Saxon craftspeople excelled in metalworking and considered it to be an important art form. Anglo-Saxon, *Great Square-Headed Brooch*, 6th century. Copper alloy with gilding and niello inlay. L. 5-5/16″ (13.5cm). The Metropolitan Museum of Art, Purchase, Rogers Fund and Alastair B. Martin, Levy Hermanos Foundation Inc., and J. William Middendorf II Gifts, 1985 (1985.209) Image © The Metropolitan Museum of Art.

Controversy and Control

Art is often controversial. It sparks heated debates and provokes strong opinions. Art can make you see, think, and feel differently about something. For many artists that is one of the major motivations for creating art.

Yet because art often sets itself apart from what we have come to expect, it can also offend people and cause an intense negative reaction. Throughout the history of art, many controversies have occurred. People's opinions have been much divided over how—or whether—to control certain choices that artists make and the audiences they reach. Dealing with such divisive issues is never easy and rarely decisive. Learning how to handle such problems also poses a challenge since controlling another's

work—whether in content, style, or diffusion—soon runs the risk of turning into censorship.

Issues of Censorship

Censorship is the suppression or deletion of anything considered objectionable. But who decides what is objectionable? What is unpleasant or offensive to you might not be disagreeable to me. How can we set guidelines to determine whether something is offensive? Is suppressing this material necessary? These are all tough questions without firm answers.

Sometimes censorship takes subtle forms. Take the case of the Paris Salon, once the official exhibition of the School of Fine Arts in France that could make or break an artist's career and reputation. The Salon had a long tradition that dated from the school's founding in the 1600s; it too established a hierarchy of arts that esteemed certain types of painting over others. In the 1870s and 1880s, artists working in a new style that came to be called *Impressionism* submitted their works for consideration by the Salon jury. Given the immense popularity of Impressionist paintings today, you may find it hard to believe that such works initially met with hostility and were rejected by the judges. Among the artists rejected by the Salon were Claude Monet, Edgar Degas, and Mary Cassatt, whose painting *Susan Comforting the Baby* (**Fig. 15**), from about 1881, shows the style judges and critics at the time objected to.

Figure 15 Mary Cassatt's work is popular today, but in the 1800s this style of art was rejected by the official Salon in Paris. Mary Cassatt, *Susan Comforting the Baby*, ca. 1881. Oil on canvas, 25-5/8″ × 39-3/8″ (65.1 × 100 cm). Museum of Fine Arts, Houston; Gift of Audrey Jones Beck. 74.136.

But rather than be refused the right to show their works, the artists started their own exhibition called the Salon des Réfusés (salon of the refused ones). In this way they countered the tacit censorship inherent in the salon system and started a revolution, of sorts, among such state-sponsored institutions.

More recently, the exhibition *Sensation: Young British Artists from the Saatchi Collection* caused quite a sensation indeed when it opened at the Brooklyn Museum of Art in New York in 1999. At the center of the controversy was a painting titled *The Holy Virgin Mary* (**Fig. 16**) by Chris Ofili (b. 1968), a British-born artist of African heritage. Like many of Ofili's works, this one features vibrant colors and was technically and visually complex. It was also inspired by his travels to Africa in the 1990s. Building up the painting's surface, Ofili used layers of resin and an unusual material, elephant dung, while incorporating elements of collage with photographic images that included parts of women's bodies as well as animals. The work was offensive to some because of its materials and the religious subject matter implied by the title. Rudolph Giuliani, then the mayor of New York City, was especially offended and threatened to take away the public funding the museum had received from the city. The artist countered that those who attacked the work actually attacked their own interpretations and not his intentions in creating the work. Reportedly, Ofili's intention here and in many of his painting is to incorporate his African ancestry and experiences. This includes accentuating the connection to the earth, and many of his works use dung as one of the mediums to reinforce that link between the subject matter, the earth, and our earthly lives. This dispute raises the issue: Do we rely on the intention of the artist or the interpretation of the viewer? What if the intended message is not the one that the viewer receives? Should the work "speak" for itself or should the artist make additional comments? And are conflicting interpretations among viewers valid?

Ultimately, the show stayed open and funding remained intact at that time. However, the ongoing debate raised questions integral to the future of art, its place in museums, and the role of museums as cultural institutions. Should some art be seen by only certain segments of the population, such as those over 18 years old? What role should government play in deciding the content of materials meant for public consumption? Would you want your money used to support art, an idea, or an issue that you don't agree with? Clearly the argument over control releases an entire Pandora's box of new problems and concerns. Yet such disagreements and discussions are fundamental to art, people, and society.

High Values, High Risks

Our society places a high value on art. This value is both intrinsic and extrinsic; the art is valued not only for its own characteristics and qualities but also for reasons external to itself—its monetary worth. Many works of art are worth millions of dollars, and an active art market ensures that prices grow steadily. Art is a commodity.

That art is worth so much is both an advantage and a hardship for museums. On the one hand, people are willing to pay steep admission prices to see highly valued art by famous artists. On the other hand, many museums face increasing obstacles to

Figure 16 Chris Ofili, *The Holy Virgin Mary*, 1996. Paper collage, oil paint, glitter, polyester resin, map pins, elephant dung on linen, 7′ 11″ × 5′ 11-5/6″. The Saatchi Collection, London.

purchasing art, and much of the art that museums own is vulnerable to theft. As thieves become more sophisticated, so too must museum security, an increasingly expensive burden for museums to bear.

Conclusion

You have learned about many of the present-day challenges facing museums, curators, and the public. These difficulties often revolve around fundamental questions such as, What is art? Who makes that determination? What art can and should be exhibited? The increasing value of art puts equally mounting pressure on museums to provide ample security as thieves are willing to take dangerous risks for the high rewards that art brings.

For Your Consideration

At the beginning of your course write a few sentences discussing what art is to you. Then put the paper away. During the last week or two of the course, reread your definition of art. Would you change it now? If so, how and why? If not, why not?

Find a work of art that you consider controversial. Describe first what you see. Then describe what you feel when you look at it and then what you think about it. Should this work appear in a museum exhibition? Why or why not? Would you argue for censorship or not?

Review the information presented in Chapter 8 on Marcel Duchamp's work called *Fountain* (see Fig. 12). If you had been on the committee that decided what could and could not be exhibited at the American Society of Independent Artists, would you have allowed this work to be in the show? Why or why not? What would have been your criteria for acceptance or rejection?

CHAPTER 10
Inside the Art Museum

Even after reading this book and visiting a museum or two, you may still wonder what goes on in museums. Who works behind those doors and what do they do? Let's take a look behind the scenes to demystify these unique cultural institutions and discover more about the knowledgeable staff members who make them "tick."

What Goes On in the Museum?

Museums are busy places, as you will likely notice when you visit. They serve distinctive, vital functions in the community. First and foremost, art museums exist to collect art. But along with the quest for acquisitions comes a long-term, expensive commitment to preserving, exhibiting, and interpreting these works. This mission further impels the museum to teach people about the role that art plays in societies past and present and to inform them about the ways that art can affect our daily lives.

Collecting Art

As you learned in Chapter 1, the idea of the present-day museum developed out of several earlier trends, including medieval church treasuries and cabinets of curiosities as well as the later Enlightenment ideal, popular in the 1800s, that people should learn about diverse areas of knowledge. Museums also fulfill the human desire to collect "stuff" and assemble groupings of objects. But how do museums decide what to collect?

Artworks enter museum collections through two ways: purchase and donation. According to its mission, each museum determines the areas in which it will collect (for example, art from a particular period, country, or style) and then decides how funds will be allocated for the purchase and maintenance of artworks. Curators are primarily responsible for acquiring works, and they look to balancing the collection—strengthening its weaknesses and acquiring the best possible examples. They rely on their expertise when considering art to be brought into the collection (accessioning) or removed from it (deaccessioning). They must also make sure that the work has a clear *provenance*—that the record of ownership proves that the work can be legally purchased.

Preserving Art

Over time, art objects deteriorate. The museum preserves and conserves works of art for future generations. Conservators evaluate an object's condition and, if damage exists, recommend repairs or methods to stop further deterioration. Conservators also

determine how to exhibit or store the works. For example, to prevent a painting on wood panel from cracking or warping, it needs to be kept in an area protected from direct sunlight and equipped with controlled temperature and humidity levels. Artworks that are sensitive to light, such as watercolors, textiles, and photographs, must be stored in a dark place and displayed only for brief periods and under low lighting conditions. The needs and complexities of art conservation are constantly changing, and conservators continue to explore new technologies to aid them in their work.

Exhibiting Art

Collecting art has little meaning, however, if no one can see it. Remember that museums display only a portion of the works they own. Curators must decide which works best represent the collection. And, as you learned in Chapter 2, museums display art in a variety of ways—chronologically, thematically, stylistically—in galleries and exhibitions organized by them or other institutions. In the past, museum display cases were stuffed with myriad, sometimes unrelated, objects that were difficult to appreciate individually. Today's museums take a different approach. To arouse interest and enthusiasm about art and to effectively communicate with audiences, many use dramatic lighting, appealing wall colors, and carefully designed spaces to attract visitors and focus their attention. Some also offer audio guides and brochures to aid in the visitor's experience and appreciation of the art.

Interpreting Art

Education is one of the primary goals of most museums. This teaching includes your experience in the galleries. Many museums provide labels and text panels with general information about the art (see Chapter 3). Special exhibitions are usually accompanied by an exhibition catalogue with informative essays and images.

Museums often offer gallery talks and tours as well as studio art and art history classes. Some may host concert and film series or dance or musical performances. Check the museums in your area to see what types of educational programs are available.

Who Works in the Museum?

Many museums are organized like a large business or corporation; they have a director, administrators, and a range of staff with specialized training and expertise.

The museum director provides the leadership and vision for shaping the institution's future. The position requires excellent skills in management, fund-raising, and supervising staff. Most museums also have a board of directors made up of committed community members from a broad spectrum of professions. Each board member supports the museum's mission and contributes time, energy, expertise, and money to achieve the museum's mission. The board is usually consulted in conjunction with the museum administration and staff to assist in making important decisions about the present and future of the museum and its collections.

The primary duty of the museum curator is the care and interpretation of art in the collection. Curators research the provenance of works, conceive of and execute exhibitions, publish books, and decide whether to purchase works or to sell parts of the collection. The responsibility of the preservation of the art falls to the conservator. Conservators evaluate the condition of objects, repair and conserve them, and recommend appropriate conditions for their display, storage, and loan to other museums.

In addition, a wide range of support staff work in interesting and integral jobs in the museum. The registrar maintains records of all the objects within the collection and is responsible for knowing the location of each object, whether it is in a gallery, in storage or conservation, or on loan. Registrars also oversee all aspects of objects loaned to other institutions, such as packing and shipping, insurance, transportation, customs, and security. Preparators are responsible for moving art within the museum. They often work closely with exhibition designers, who create the eye-catching displays in the galleries. Museum educators develop and implement interesting programs for adults and children. They provide and organize lectures, classes, and training, especially for docents. Some museums have libraries whose librarians care for the books, manuscripts, and other documents related to art and aspects of the collection.

Connecting with the Museum

Now that you better understand art museums and all that they can offer, you may be inspired to become active in or supporting a local, or distant, museum. Developing a strong relationship with an art museum can enrich your life, exposing you to interesting new people and experiences.

Membership

Become a member. Memberships are one of the major sources of support for museums. You can feel good about giving back to a place that offers you such worthwhile experiences while enjoying free or reduced admission, as well as discounts at the museum shops and restaurants, and concerts, films, and other special events.

Volunteers and Docents

One of the most rewarding ways to become involved with an art museum is to volunteer. Most museums need volunteers to help with special programs, events, and everyday activities. Assignments may include greeting visitors, working on special projects, or general office duties such as mailings and filing. Contact the volunteer coordinator at your local museum for more information.

Have you ever wanted to be a museum guide? Many museums offer extended educational programs for volunteers who wish to assist in educating the public about the collection. To become a docent, you must complete a course of study in the collection and in communicating with the public for the purpose of providing tours.

Internships and Continuing Education

Many colleges and universities collaborate with museums to offer internships for which you can receive college credit. Graduate students specializing in art history, art education, conservation, and related areas can apply for paid internships sponsored by museums or foundations.

Many museums also offer courses in studio art and art history for children and adults. Most programs are offered at the museum, but some may take place in schools or other local venues as part of the museum's commitment to community outreach.

Case Study: Marble Sculptures from the Parthenon— I want my marbles!

This isn't a child's argument over the game of marbles but rather a complicated legal, moral, and ethical debate that swirls around some of the surviving marble sculptures from the Parthenon (447–432 BCE). Designed by Phidias, these sculptures remained for over a millennium on the Parthenon, a temple dedicated to the goddess Athena on the acropolis in Athens, Greece. The sculptures were located on the temple pediment, the metopes, and the frieze, and in the interior of the cella there was a monumental statue of Athena herself. Although a series of events transformed the Parthenon and precipitated the destruction and dispersal of the sculptures, the controversy centers on a group of the sculptures now usually referred to as the "Elgin marbles." They have been housed in the British Museum in London since 1816 when the British government purchased them from Thomas Bruce, better known as Lord Elgin. Displayed to the public in a gallery designed especially for them, the Parthenon sculptures include 247 feet of the original 524-foot frieze, 15 of the original 92 metopes, 17 pedimental figures, and various pieces of architecture.

At the core of the controversy is the question of whether or not Lord Elgin legitimately acquired the sculptures. The British government maintains that he acquired them legally, while the Greeks argue that when Lord Elgin was an ambassador, their country was controlled by the Ottoman Turks who had no right to decide the fate of these precious sculptures which are a significant part of Greek cultural history.

Both sides want the marbles—whose should they be? Should they remain at the British Museum or be returned to Greece and what should be the legal, moral, and ethical criteria for making that decision?

Conclusion

This last chapter invites you to come inside the museum not only as a visitor but also as someone who may contribute to the museum's mission. In order to fulfill many vital functions, museums collect, preserve, and exhibit and interpret art while educating us on all these levels. A dedicated team of people with specialized, diverse skills and talents, as well as a group of involved community supporters and volunteers, ensure that the art of the past and the present will be part of the future—a testament to who we were and who we are as individuals and as a society.

For Your Consideration

Visit the website of a local art museum. Find the page that states the museum's mission. What is the museum trying to accomplish? List 3–5 of its goals.

Search the Web to find information about the recent conservation work on Pablo Picasso's *Les Desmoiselle d'Avignon*, completed at the Museum of Modern Art in New York (see Fig. 9). What was done? How have people reacted to the changes? What effect will that have on viewing the painting?

Visit the official website of the American Association of Museums: www.aamus.org. Research and report on the types of educational degrees required for art museum directors, conservators, curators, registrars, museum educators, librarians, and preparators.

The headlines read like a movie script—respected curator of a world-renowned museum charged with the illegal acquisition of millions of dollars of antiquities on the international market. Unfortunately, this is not fiction. The Italian government has brought allegations against the Curator of Antiquities, Marion True, at the J. Paul Getty Museum in Los Angeles. These allegations focus on approximately 40 objects including a fifth-century BCE sculpture of Aphrodite, goddess of love and beauty, reportedly worth over 20 million dollars when it cleared U.S. Customs in 1987. Check the Web and research the background and the on-going status of this case that will likely have long-range implications.

Appendix A
List of Major U.S. Museums and Their Websites

This list features U.S. art museums that also have websites. All the museums mentioned in the text are included, as are many others in different regions of the country, in the hope of making the collections more accessible to you on the Web and in person.

New England

Connecticut

Hartford
The Wadsworth Atheneum www.wadsworthatheneum.org

New Haven
Yale Center for British Art www.yale.edu/ycba

New Haven
Yale University Art Gallery http://artgallery.yale.edu

Massachusetts

Amherst
The Mead Art Museum at Amherst College www.amherst.edu~mead

Boston
Isabella Stewart Gardner Museum www.gardnermuseum.org
Museum of Fine Arts, Boston www.mfa.org

Cambridge
Harvard University Museums www.artmuseums.harvard.edu

Lincoln
DeCordova Museum and Sculpture Park www.decordova.org

North Adams
Massachusetts Museum of Contemporary Art www.massmoca.org

Salem
Peabody Essex Museum www.pem.org

Williamstown
Clark Art Institute www.clarkart.edu

Worcester
Worcester Art Museum www.worcesterart.org

Maine

Portland
Portland Museum of Art www.portlandmuseun.org

New Hampshire

Hanover
Hood Museum of Art www.museum.dartmouth.edu

Manchester
Currier Museum of Art www.currier.org

Rhode Island

Providence
Rhode Island School of Design Museum www.risd.edu/museum

Vermont

St. Johnsbury
St. Johnsbury Athenaeum www.stjathenaeum

The Mid-Atlantic

Delaware

Wilmington
Delaware Art Museum www.delart.org

Winterthur
Winterthur Museum, Garden, and Library www.winterthur.org

New Jersey

Princeton
Art Museum at Princeton University www.princetonartmuseum.org

New York

Beacon City
Dia: Beacon www.diabeacon.org

New York City
Brooklyn Museum www.brooklynmuseum.org
Frick Collection www.frick,org
Guggenheim Museum www.guggenheim.org
Metropolitan Museum of Art www.metmuseum.org
Museum of Modern Art www.moma.org

Maryland

Baltimore

Baltimore Museum of Art www.artbma.org
The Walters Gallery www.thewalters.org

Pennsylvania

Allentown

Allentown Art Museum www.allentownartmuseum.org

Philadelphia

Philadelphia Museum of Art www.philamuseum.org

District of Columbia

Corcoran Gallery of Art www.corcoran.org
Hirshorn Museum and Sculpture Garden http://hirshorn.si.edu
National Gallery of Art www.nga.gov.home.htm
National Museum of the American Indian www.nmai.si.edu
Phillips Collection www.phillipscollection.org
Sackler Freer Galleries www.asia.si.edu

The South

Alabama

Birmingham

Birmingham Museum of Art www.ARTSbma.org

Florida

Miami Beach

Wolfsonian – Florida International University www.wolfsonian.fiu.edu

Sarasota

John and Mable Ringling Museum of Art www.ringling.org

St. Petersburg

Salvador Dali Museum http://salvadordalimuseum.org

Georgia

Athens

Georpgia Museum of Art www.uga.edu/gamuseums

Atlanta

High Museum of Art www.high.org

Kentucky

Lexington

University of Kentucky Art Musuem www.uky.edu/ArtMuseum

Louisiana

New Orleans
New Orleans Musuem of Art www.noma.org

North Carolina

Durham
Nasher Museum of Art at Duke University www.nasher.duke.edu

Chapel Hill
Ackland Art Museum www.ackland.org

South Carolina

Charleston
Gibbes Museum of Art www.gibbesmuseum.org

Greenville
Bob Jones University Museum and Gallery www.bjumg.org

Tennesse

Chattanoga
Hunter Museum of American Art www.huntermuseum.org

Nashville
Vanderbilt University Fine Arts Gallery http://sitemason.vanderbilt.edu/gallery

Virginia

Charlottesville
University of Virginia Art Museum www.virginia.edu/artmuseum

Richmond
Virginia Museum of Fine Art www.vmfa.state.va.us

West Virginia

Huntington
Huntington Museum of Art www.hmoa.org

The Midwest

Illinois

Chicago
The Art Institute of Chicago www.artic.edu
Museum of Contemporary Art www.mcachicago.org
The Oriental Institute Museum http://oi.uchicago.edu

Indiana

Bloomington
Blooomington Indiana University
 Art Museum www.indiana.edu/~iuam/ium_home

Indianapolis
Indianapolis Musuem of Art www.ima-art.org

Iowa

Iowa City
University of Iowa Museum of Art www.uiowa.edu/uima

Kansas

Lawrence
University of Kansas Spencer Museum
 of Art www.ku.edu/~sma

Michigan

Ann Arbor
University of Michigan Musuem of Art www.umma.umich.edu

Detroit
Detroit Institute of Arts www.dia.org

Minnesota

Minneapolis
Minneapolis Instiute of Arts www.artsmia.org

Missouri

Kansas City
Nelson-Atkins Museum of Art www.nelson-atkins.org

Saint Louis
The Saint Louis Art Museum http://stlouis.art.museum

Nebraska

Omaha
Joslyn Art Musuem www.joslyn.org

North Dakota

Fargo
PlainsArt Museum www.plainsart.org

Ohio

Cleveland
Cleveland Museum of Art www.clevelandart.org

Dayton
The Dayton Art Institute www.daytonartinstitute.org

Toledo
Toledo Museum of Art www.toledomuseum.org

Wisconsin

Milwaukee
Milwaukee Art Museum www.mam.org

Madison
Elvehjem Museum of Art at the University www.lvm.wisc.edu
 of Wisconsin, Madison

The Southwest

Arizona

Phoenix
Heard Museum Native Cultures and Art www.heard.org
Phoenix Museum of Art www.phxart.org

Tuscon
Tuscon Museum of Art www.tusconmuseumofart.org
University of Arizona Museum of Art http://artmuseum.arizona.edu

Oklahoma

Norman
Fred Jones Jr. Museum of Art, www.ou.edu/fjjma
 University of Oklahoma

New Mexico

Santa Fe
Georgia O'Keeffe Museum www.okeeffemuseum.org

Texas

Dallas
Dallas Museum of Art www.dallamuseumofart.org

Houston
Museum of Fine Arts, Houston www.mfah.org

Fort Worth
Amon Carter Museum www.cartermuseum.org
Kimball Art Museum www.kimballart.org

The West

California

Los Angeles
J. Paul Getty Museum — www.getty.edu/musuem
Los Angeles Country Museum of Art — www.lacma.org

Pasadena
Norton Simon Museum — www.nortonsimon.org

San Francisco
De Young Musuem — www.famsf.org/deyoung
San Francisco Museum of Modern Art — www.sfmoma.org

San Diego
San Diego Museum of Art — www.sdmart.org

Colorado

Denver
Denver Art Museum — www.denverartmuseum.org

Idaho

Boise
Boise Art Museum — www.boiseartmuseum,org

Oregon

Portland
Portland Art Museum — www.pam.org

Eugene
Jordan Schnitzer Museum of Art, — http://uoma.uoregon.edu
University of Oregon

Montana

Missoula
The Montana Museum of Art and Culture, — www.umt.edu.party/famus/default.htm
University of Montana

Nevada

Las Vegas
Guggenheim Heritage Musuem — www.guggenheim;asvegas.org

Washington

Seattle
Seattle Art Museum — www.seattleartmusuem.org

Spokane
Northwest Museum of Art and Culture — www.northwestmuseum.org

Utah

Provo
Brigham Young Museum of Art www.umfa.utah.edu

Salt Lake City
Utah Museum of Fine Arts www.umfa.utah.edu

Wyoming

Laramie
Art Museum, University of Wyoming www.uwyo.edu/artmuseum

Alaska

Anchorage
Anchorage Museum of History and Art www.anchoragemuseum.org

Fairbanks
University of Alaska Museum of the North www.uaf.edu/museum

Hawaii

Honolulu
Contemporary Museum www.tcmhi.org
Honolulu Academy of Art www.honoluluacademy.org

Appendix B
List of Major Museums in Several World Cities and Their Websites

This list features selected art museums in the world with websites. All of the museums mentioned in the text are included as are many others in the hope of making the collections more accessible to you on the Web and in person.

The African Continent

Egypt

Cairo

The Egyptian Museum	www.egyptianmuseum.gov.eg
Gezira Museum	www.egyptvoyager.com/museums_geziramuseum.htm

Kenya

Nairobi

National Museums of Kenya	www.museums.or.ke

South Africa

Capetown

Museums of Capetown	www.museum.org.za/iziko
(South African National Gallery)	

Port Elizabeth

Nelson Mandela Metropolitan	www.artmuseum.co.za

Pretoria

Pretoria Art Museum	www.pretoriaartmuseum.co.za

Australia

Canberra

National Gallery of Australia	www.nga.gov.au

Melbourne

National Gallery of Victoria	www.ngv.vic.gov.au

Perth

Art Gallery of Western Australia	www.artgallery.wa.gov.au

Sydney

Art Gallery of New South Wales	www.artgallery.nsw.gov.au

Canada

Montreal
The Montreal Museum of Fine Arts www.mbam.qc.ca

Toronto
Art College of Canada www.ago.net

Ottawa
National Gallrey of Canada http://nationalgallery.ca

Vancouver
Vancouver Art Gallery www.vanartgallery.bc.ca

Asia

China

Beijing
Arthur M. Sackler Museum www.sackler.org.china
 of Art and Archaeology

Hong Kong
Hong Kong Museum of Art www.lcsd.gov.hk/CE/Museum/Arts

Shanghai
Shanghai Museum www.shanghaimuseum.net

India

Calcutta
Indian Museum – Calcutta www.indianmuseum-calcutta.org

New Delhi
National Museum of India www.nationalmuseumindia.org

Indonesia

Surabaya, East Java
Museum Mpu Tantular www.members.tripod.com/~mputantular/index.html

Ubud, Bali
Agung Rai Museum of Art www.nusantara.com/arma

Japan

Hiroshima
Hiroshioma Museum www.hiroshima-museum.jp

Kyoto
Kyoto National Museum www.kyohaku.go.jp

Tokyo
National Museum of Western Art www.nmwa.go.jp
Tokyo National Museum www.tnm.go.jp

Philiipines

Manila
The Phillipines National Museum http://nmuseum.tripod.com

Singapore

Singapore
Singapore Art Museum www.nhb.govsg/SAM

South Korea

Seoul
Seoul Metropolitan Musuem of Art www.metro.seoul.kr/muse/eng/index.html
National Museum of Contemporary www.moca.go.kr/Modern/eng
 Art, Korea

Thailand

Chiang Saen
Chiang Saen National Museum – ? www.chiangsaennationalmuseum.org

Taiwan

Taipei
National Palace Museum www.npm.gov.tw

New Zealand

Auckland
Auckland Art Gallery www.aucklandartgallery.govt.nz

Central America and South America

Argentina

Buenos Aires
Museo de Art Latinoamericano www.malba.org.ar
 de Buenos Aires

Brazil

Rio de Janiero
Museu de Arte Moderna www.mamrio.org.br
 Rio de Janiero

Sao Paolo
Museu de Arte Brasileira www.faap.br/museu/museu.htm

Chile

Santiago
Museo Naciaonal de Bellas Artes www.dibam.cl/bellas_artes

Columbia

Bogata
Museo del Oro www.banrep.gov.co/museo

Costa Rica

San Jose
Museo de Arte Costarricense http://ns.cr/arte/musearte/musearte.htm

Mexico

Mexico City
Museo de Nacional de Arte www.cnca.gob.mx/cnca/buena/inba/subbellas/
 museos/munal.index.html

Museo Mural Diego Rivera www.arts-history.mx/museos/mx

Peru

Lima
Museo de Arte de Lima http://museoarte.perucultural.org.pe

Uruguay

Montevideo
Museo Nacional de Artes Visuales www.mnav.gob.uy

Europe

Austria

Vienna
Kunsthistoriches Museum Vienna www.khm.at
Liechenstein Museum www.liechensteinmuseum.at
Albertina Graphic Arts Collection www.albertina.at

Belgium

Antwerp
Koninklijk Museum Voor Schone http://museum.antwerpen.be/kmska
 Kunsten

Brussels

Royal Museum of Fine Arts www.fine-arts-museum.be
 of Belgium

Tervuren
Royal Museum for Central Africa www.africamuseum.be

Croatia

Zagreb
Strossmayer's Old Master Gallery – www.mdc.hr/strossmayer/eng/index.html
 The Croatian Academy of
 Science and Art

Czech Republic

Prague
Prague National Art Gallery www.ngprague.cz

Denmark

Copehagen
Statens Museum for Kunst www.smk.dk
Copenhagen Art Gallery www.copenhagen~art.dk

Estonia

Tallin
The Art Museum of Estonia www.ekm.ee/english/algus/htm

Finland

Helsinki
Finnish National Gallery www.fng.fi

France

Paris
Centre George Pompidou www.centrepompidou.fr
Louvre Museum www.louvre.fr
Musee d'Orsay www.musee-orsay.fr

Nice
Matisse Museum of Nice www.musee-matisse-nice.org

Versailles
Chateau de Versailles www.chateauversaiiles.fr

Germany

Berlin
Staaliche Museen zu Berlin www.smb.spk-berlin.de

Dresden
Staaticlhe Kunstammlungen Dresden www.skd-dresden.de/de/index.html

Stuttgart
Staatsgalerie Stuttgart www.staatsgalerie.de

Munich
Alte Pinakothek www.pinakothek.de

Greece

Athens
National Archaeological Museum www.culture.gr
 of Athens
National Museum of Contemporary www.ernst.gr
 Art
The Nicholas P. Goulandris www.cycladic-m.gr
 Museum of Cycladic Art

Hungary

Budapest
Ernst Museum www.ernstmuseum.hu/intro.php

Iceland

Rekjavik
National Gallery of Iceland www.listasafn.is
Reykjavik Art Museum www.listasafnreykjavikur.is

Ireland

Dublin
National Gallery of Ireland www.nationalgallery.ie

Italy

Florence
Uffizi Gallery www.polomuseale.firenze.it/musei/uffizi
Galleria del'Academic www.polomuseale.firenze.it/musei/accademi
Museo del Bargello www.polomuseale.firenze.it/bargello

Naples
Museo Archeologico Nazionale www.marketplace.it/museu.nazionale
 di Napoli

Rome
Capitoline Museums www.museicapitolinni.org
Borghese Gallery www.galleriaborghese

Vatican City
Vatican Museum http://mv.vatican.va

Venice
Peggy Guggenheim Collection www.guggenheim-venice.it
Gallerie dell'Accademia www.gallerieaccademia.org
Museo Correr www.museiciviciveneziani.it

Latvia

Riga
State Art Gallery www.vmm.lv/lv

Lithuania

Vilnius
Lithuanian Art Museum www.ldm.it

Luxembourg
Musee National d'histoire d'art www.mnha.public.lu

Netherlands

Amsterdam
The Rijksmuseum www.rijksmuseum.nl
Van Gogh Museum www.vangoghmuseum.nl

Hague
The Mauritshuis – Royal www.mauritshuis.nl
 Picture Gallery

Norway

Oslo
Nasjonalmuseet for Kunst, www.nasjonalmuseet.no
 Arkitektur og Design
Munch Museum www.munch.museum.no

Poland

Warsaw
Polish National Museum www.mnw.art.pl

Portugal

Lisbon
Museu Calouste Gulbenkian www.museu.gulbenkian.pt

Russia

Moscow
Pushkin Museum of Fine Art www.museum.ru/gmii

St Petesburg

The State Hermitage Museum www.hermitagemuseum.org

Spain

Bilboa
Guggenheim Bilboa www.guggenheim-bilbao.es/ingles/home.htm

Madrid
Musei Nacional Centro www.museoreinasofia.es
 de Arte Reina Sofia
Museo Nacional del Prado www.museoprado . .es

Sweden

Stockholm
National Museum www.nationalmuseum.se

Switzerland

Basel
Kunstmuseumbasel www.kunstmuseumbasel.ch/en.html

Zurich
Kunsthaus Zurich www.kunsthaus.ch

United Kingdom

England

Cambridge
The Fitzwilliam Museum www.fitzwilliam.cam.ac.uk

London
The British Library www.bl.uk
The British Museum www.thebritishmuseum.ac.uk
The National Gallery www.nationalgallery.org.uk
The Tate Gallery www.tate.org.uk
The Tate Modern www.tate.org.uk/modern
Victoria and Albert Museum www.vam.ac.uk
The Courtauld Institute of Art www.courtauld.ac.uk
 of the University of London

Oxford
Ashmolean Museum of Art www.ashmol.ox.ac.uk
 and Archaeology

Northern Ireland

Belfast
Ulster Museum www.ulstermuseum.org.uk

Scotland

Edinburg
National Galleries of Scotland www.nationalgalleries.org

Wales

Cardif
National Museum and Gallery www.museumwales.ac.uk/en/home
 of Wales .

Middle and Near East

Iran

Tehran
Tehran Museum of Contemporary Art www.tehranmoca.com

Iraq

Baghdad
Dijila Art Gallery www.dijlaart.com
Iraq Museum International www.baghdadmuseum.org

Israel

Jerusalem
The Israel Museum www.imj.org,il

Tel Aviv
The Tel Aviv Museum of Art www.tamuseum.com

Jordan

Amman
Jordan National Gallery of Arts www.nationalgallery.org/Intro.html

Kuwait

Hawallli
Tareq Rajab Museum http://trmk.com

Kuwait City
The National Museum www.kmia.org.kw

Turkey

Istanbul
The Topkapi Palace Museum www.ee.bilkent.edu.tr/!history/topkapi.htm
Istanbul Modern www.istanbulmodern.org

Glossary

abstract art art that exaggerates certain aspects of a person(s) or object(s) but that remains recognizable

accession to complete the records, including assigning an identifying number, to officially bring a work of art into the museum's collection

acquisition a work of art brought into the museum collection

aesthetics a branch of philosophy that deals with the study of beauty and what is beautiful

architecture the art and science of building; also the buildings themselves and the way space is arranged

attribution to designate the creation of a work of art to a particular person or workshop

cabinet of curiosities collections of natural and human-made objects aimed to encapsulate knowledge

classical-revival style a style of architecture that looks back to the Classical period of ancient Greece and Rome

connoisseur an expert; in art, one with well-developed visual abilities for looking at art and analyzing visual qualities to determine its author as well as the time and place of creation

conservation the study of an artwork to assess its physical condition, to prevent further damage, and to repair or restore it if necessary

curator a person responsible for the care and interpretation of objects, especially art in a museum collection

curvilinear line(s) moving along a curve

deaccession the process of removing art from the museum's collection

exhibition a public showing of art objects, which are often linked by artist, medium, or theme

form the visual aspects of art, such as line, color, texture, spatial qualities (mass, volume, and space), and composition

formal analysis the study of the visual aspects of art, including form and content; also called visual analysis.

graphic arts two-dimensional artworks focusing on line and value (rather than color); includes drawing, printmaking, and photography

iconography an approach to studying art that focuses on subject matter and the symbols associated with it

iconology an approach to studying art that looks at the religious, historic, social, and cultural context of the creation of an artwork

installation art art created for a specific location and often meant to be displayed only for a limited time

major arts a traditional hierarchy within art history; includes painting, sculpture, and architecture

medium the material(s) and techniques used in making a work of art

methodology the approaches for studying art, including formal (visual) analysis, iconography, and iconology

minor arts a traditional hierarchy within art history; includes art often having a practical function as well as an aesthetic aspect, such as metalwork, textiles, and decorative arts

narrative the depiction in art of a story or event

nonrepresentational art art that does not show a recognizable person or object

oeuvre the body of work created by an artist or architect during his/her lifetime

perspective a pictorial device for creating the illusion of space or three dimensions on a two-dimensional surface; includes vertical, atmospheric or aerial, linear or one-point, two-point, and reverse perspective

provenance the history of ownership of an artwork

relief sculpture three-dimensional form that projects from the main surface; *high* and *low* refer to the level of projection from the surface

representational art art that shows something recognizable

sculpture in the round sculpture that stands on its own and is meant to be viewed from all sides; also called *freestanding sculpture*

style in art, a distinctive manner of expression (in both form and content) that may be linked to a historical period, an individual or group of artists, or a specific culture

two-dimensional art art that is created on a flat surface, such as painting, drawing, or photography; usually has a foreground, middle ground, and background

three-dimensional art art that takes up space with height, width, and depth; includes architecture and sculpture

transhistorical something that transcends historical boundaries

triptych a work of art (traditionally an altarpiece) with three distinct panels

virtual museum web site sponsored by art museums

Notes

Notes